A Doctor For All Seasons

A
Doctor
For All
Seasons

DR JOHN GAYNER

SilverWood

Published in 2021 by SilverWood Books

SilverWood Books Ltd
14 Small Street, Bristol, BS1 1DE, United Kingdom
www.silverwoodbooks.co.uk

ISBN 978-1-80042-091-5 (hardback)
ISBN 978-1-80042-090-8 (paperback)
ISBN 978-1-80042-092-2 (ebook)

British Library Cataloguing in Publication Data
A CIP catalogue record for this book is
available from the British Library

Page design and typesetting by SilverWood Books

For Nicky at home and Hilary at the practice

Prologue

It's the second week in June 2000, and I am clearing my desk at the practice in Sloane Square before driving to Queen's Tennis Club where I am the tournament doctor. I like to arrive at least an hour before play starts in case any player has an issue that requires treatment, or to register the withdrawal of a player from the tournament. Play starts at 12.30 and, checking my watch, I see it's already 11.30. My secretary, Hilary, rings through to say that there is an emergency. Before I can argue, Hilary walks in with a new patient sheet, followed by the emergency, an actress called Angelina Jolie. She walks in hesitantly on what transpires to be an knee injury.

Ms Jolie sits down and, after a handshake, tells me she is playing the lead role in an action-adventure film based on the

Tomb Raider video game series featuring the character Lara Croft. She explains that filming has not yet started, but she is involved in rehearsals and training for the stunts which she is scheduled to perform. As I subsequently discover, when I visit her in her hotel, she has a range of weightlifting and gym equipment in her room. However, the accident that has brought her to me has occurred in a gym, where she has fallen from a climbing frame injuring her knee. I examine the knee, which is definitely painful on movement, and I come up with a solution that will allow me to examine it more thoroughly.

"Angelina, I am the tournament doctor at Queen's Club, and I am about to go there now. We have an ultrasound machine and the best musculo-skeletal radiologist in England who can scan your knee. Will you come to Queen's with me now?"

Her "Yes" means that I will not be late and I can more thoroughly investigate the damage she has done. As we leave the practice, anxious telephone calls are coming in from all quarters, enquiring about her injury, and my prognosis. The film's producers, director and insurers all have vested interests in the outcome of my consultation.

As we drive through the gates of Queen's Tennis Club, a few spectators gaze at us in surprise and, when I park, we are descended upon by snapping paparazzi. I always thought that the paparazzi were forewarned of a film star emerging from a restaurant or suchlike, but these sports photographers are already at Queen's and have jumped at this unexpected opportunity for additional coverage. She must be well known, I think to myself. She is certainly very striking and, other than her injured knee, very fit.

We walk to the clubhouse and I take her up the back staircase to the corridor leading to my treatment room. The corridor is also

used by the players, and I am anxious not to embarrass Ms Jolie by walking her past a semi-naked or even naked player, so I ask her to wait while I check that the coast is clear. Assured of no unexpected nakedness, we go into the doctor's room, where Jerry Healy, the musculo-skeletal radiologist, starts to screen the knee. After a while, there comes a persistent loud knocking on the door, followed by an American voice.

"Taking quite a time in there, doc. There is a long queue waiting to be seen here." I pause and open the door a couple of inches to reassure the waiting patients that I will see them soon.

With the scanning complete, I say, "Angelina, I think a player spotted us sneaking in here. There are a number out there now who would like to meet you. Are you up for this?"

She agrees with a nod of the head and I open the door to Pete Sampras, Wimbledon champion, and other world-class tennis players. Celeb meets celeb, and there are smiles all around.

As for the knee, it recovers in time for principal photography (filming) to begin in mid-July, and I arrange for a physiotherapist to be with her during filming at the Ta Prohm Temple in Cambodia.

An over-rider occurs in September when I meet Jon Voight, who had been cast as Lord Richard Croft in the same movie, as real-life father and daughter play an on-screen father and daughter. This is an important reconciliation for the pair whose relationship has previously been difficult. Jon had played Joe Buck in the 1969 film, *Midnight Cowboy*, in which Dustin Hoffman had also starred. The film had been a huge hit, winning three Academy Awards and Best Actor nominations for both Voight and Hoffman.

Jon, like Angelina, also had to have a cast medical before filming in *Tomb Raider*. I told him how much *Midnight Cowboy*

had been the film to watch in my student days, and that Dustin Hoffman had bought our home in Kensington in 1985, when it was sold after my first marriage had come apart.

During this consultation he notices I have a golf putter propped against a bookshelf.

"Doc, I see you play golf," he says.

"Yes, I'm just starting. Do you play?"

"Yes. My father, Elmer, was the professional at a country club, so I started playing as a boy and, by 16, I was winning all the tournaments locally in my age group. I was already interested in acting, and it was a toss-up between golf and performing. The clincher was a tournament at another club. I was walking up a hill on one of the fairways when I heard the crisp sound of cleanly hit golf shots. I looked down to the left and saw a young ginger-haired kid striking ball after ball perfectly. I said to myself, If I become a fulltime professional player, I'll find myself competing against that guy and I won't have a prayer of winning any tournaments. So, I decided to become an actor. The kid's name was Jack Nicklaus."

After qualifying as a general practitioner, I worked for film insurers, production companies and actors, where I observed accidents that do not occur in everyday life, but are caused by directors' desires for particular shots and the action misfiring. This has resulted in some unique theatrical anecdotes, which I felt were worth sharing with a wider audience than my immediate family and friends. I've scoured Gyles Brandreth's recently published *The Oxford Book of Theatrical Anecdotes*, but have found little or no overlap. I hope you enjoy reading them as much as I've enjoyed remembering them.

I

The surgical houseman

It was Monday, 3 August 1970, and I awoke with a feeling of excitement. Having just qualified, this was my first day as a junior house doctor in St Thomas' Hospital. My long white coat was the badge of honour that I would proudly wear as I walked down the hospital corridor.

I was extremely pleased to have landed my first job in the teaching hospital where I had trained, which is what we all hoped for when we had just qualified. With my white coat on, I walked down the corridor towards the Orthopaedic Department to meet the registrar who would take me to meet the patients who would be my day-to-day responsibility. I spent the afternoon reading through the patients' notes, so that I was fully up to speed for my first ward round the next day.

*

The next day, I made my way to the Orthopaedic Department, where I met the two registrars, four physiotherapists, and our boss, Mr Ronnie Furlong.

We then trooped off for my first ward round as a young doctor. There was a protocol for the way we were lined up. Being the 'Boy', I was alongside Mr Furlong. We were followed by the registrars, with the physiotherapists taking up the rear. At Doulton ward, the female surgical ward, we were joined by ten medical students.

Before entering the ward, Mr Furlong stopped to do up the buttons on his white coat, pulled up his collar and buttoned that as well. Rather bemused, I turned to see the registrars doing the same. Naturally, I followed suit, buttoned the front of my coat and lifted my collar.

In the ward, we were met by Sister Doulton, who blushed when Mr Furlong greeted her. She was an attractive 28-year-old with a nice figure and rather short hair. But she wasn't a great smiler.

It was my job to update the boss on all that had happened to the patients since he had last seen them. From time to time, he conferred with the physios to inquire after the progress of patients regarding their joint movements and their rehabilitation.

When the ward round was finished, we walked back out through the double doors. Once the doors had closed, the boss undid his buttons and put his collar down. I turned to see the registrars doing the same and, once again, I followed suit. Mr Furlong turned to me.

"Chilly in there isn't it, dear boy?"

Still confused, but compliant, I replied, "Yes, sir."

"Sister Doulton is rather a freezer." And he continued, "You were not chosen solely for your medical expertise, but because

you are a robust rugby player and popular with the nurses. So, you are going to take Sister Doulton out and give her a thorough warming up."

The registrars and physios were all smiles, as this was clearly the same routine that had been played out before with every new boy on the block. Naturally, it took me by surprise.

Being Mr Furlong's houseman was clearly not going to be dull and the boss could well have been the inspiration for Richard Gordon's larger-than-life hospital consultant Sir Lancelot Spratt in *Doctor in the House*.

Two weeks had passed and I was now in the routine of accompanying Mr Furlong every Tuesday afternoon to see the outpatients, and consultations would be conducted in front of students. We met in the Orthopaedic Department at 1.45, at which point, the orthopaedic secretary, Miss Webster, stood bolt-upright, flushed in the face with excitement at seeing Mr Furlong. He signed letters, read correspondence, and then turned to me with the question: "Do I have to, dear boy?"

"Yes, sir."

"Pearls before the swine," he would always reply, as we walked off to meet the outpatients.

Each patient had already been seen by a medical student, who would take a history, examine the patient, and look at recent test results, which, in the case of orthopaedic patients, almost always included an X-ray. Each patient would lie on a couch while the student went through what he had learned about the patient's symptoms and history, and Mr Furlong would then ask him to examine the patient in front of us and describe any physical signs he had elicited.

Two years earlier, in 1968, I had been one of those medical students. I remember the process could sometimes lead to unexpected consequences. On a different surgical ward round, early in my student days, one of the students, Johnson, was examining a 25-year-old blonde from Lambeth. The general surgeon asked Johnson to explain why the young woman was in hospital.

"Well, sir, she was seen by you in outpatients and you put her down for an admission as soon as possible," Johnson began.

"No, no. I mean what symptom did she complain of that made her GP refer her to outpatients?" asked the surgeon.

"Well, sir," said Johnson, blushing, "she had noticed a lump in her breast."

"Okay, which breast was it, Johnson?"

"The right one, sir."

"Sister, will you please pull the curtain round the bed."

"And now Johnson Will you please examine the patient and demonstrate where you locate the lesion."

Johnson ran his hands over the patient's breasts and, seeming relieved when it was all over, stood back.

"Johnson, now that you have completed the social examination, I think you should start the clinical examination."

It was one of those moments in life when the unlucky mug involved would have liked a hole to open in the floor into which he could disappear!

Back with the orthopaedic outpatients, Mr Furlong was telling the rather serious student how to proceed.

"Before you present the history etc., I do not want you to tell me on which side of the body he has the lesion."

The student began to present the history of a 30-year-old man who had injured his knee playing football six weeks earlier. The knee was clicking, causing the man pain when he moved it and it had even given way on a couple of occasions.

"Thank you, Lewis, for your very clear presentation of the clinical details. Before you demonstrate the injury, I will tell you which knee is the injured one."

At this, we all peered at the knees, which looked similar in all respects, and neither with any signs of redness or swelling.

Mr Furlong pointed to the right knee.

"Is this the one?"

"Yes, but how…?"

"Look at the muscles above the knees," the boss directed us. "You will see that the quadriceps (muscle above the knee) on the right-hand side are wasted and thinner than on the left."

He took a measuring tape.

"Take six inches above the top of the patella and measure the circumference of each leg. Record that for future reference. In this case, there is a two-inch difference. So, Lewis, what do you recommend as our course of action?"

"We should definitely operate, sir."

"Now listen to me," said Mr Furlong. "When you are on the operating table you are nearer to God than at any other time in your life."

Lewis looked crestfallen, clearly struggling with the rejection of his opinion.

We returned to our desk, while we waited for the next patient.

Ronnie whispered to me, "Did I say something wrong? Lewis did not look very happy."

"Well, sir," I informed him. "He is president of the Student Christian Union, and I think that he doubts your theological assessment of the situation."

The next patient presented with a hand on which the ring and little fingers were bent and could not be straightened. The hand had been like this for several years, but had recently been getting worse and the patient wanted to do something about it. The condition was Dupuytren's contracture, caused by fibrous adhesions in the palm of the hand preventing movement of the tendons needed to straighten the fingers. It is, in fact, the most common hereditary disorder of connective tissue. But there is another factor that causes the condition – booze. I distinctly remember that because of Mr Furlong's explanation.

"Go to the private members' club "The Athenaeum," in St James's," he said. "After lunch, go upstairs to the long room, and stroke the palms of the well-lunched sleeping bishops, and there you will find Dupuytren's contracture."

The next patient was a 60-year-old woman, who presented with a large scar on her hip from where she had previously undergone surgery which had gone terribly wrong. She was experiencing instability, and pain on movement. She had been in a car crash and had been lucky to survive at all.

"Look at this X-ray," the boss told us. "This is a ring prosthesis with a metal cup and a metal replacement head and neck of femur. These nearly always lead to trouble because of the reaction of metal on metal. The hip replacements that we do here at St Thomas' have a plastic cup and a metal head of femur."

Mr Furlong turned to me and asked, " Where was this operation done?"

"St George's Hospital, sir."

"Listen to me. Orthopaedics is on ice at the moment at St George's, I'm afraid.

"Now, girls," he said to the female students as he pointed his next words of wisdom at them. You are in a taxi coming home from a party, travelling up Park Lane, and the taxi swerves to avoid a car that pulls out in front, forcing the taxi to crash into the central reservation. Do not keep your legs together as Mummy told you, because this could result in a fractured neck of femur and then the head of the femur has the distinct risk of dying, resulting in you needing a full hip replacement. So, open your legs, so that the head of femur can go straight into the hip, saving you from a fractured neck of femur."

Mr Furlong's outpatient clinics were always well attended and memorable.

St Thomas' was the hospital used by the Metropolitan Police, and we had a regular flow of injured motorcycle police who had taken tumbles when chasing down criminals. But more of that later.

We were in the Orthopaedic Department discussing the best way to handle a 25-year-old policeman with a nasty tumour, a sarcoma, in his upper leg. Before the meeting, the registrars had been sifting through the latest academic research on the subject to decide on the best way to treat him. There were several options, including amputating the leg above the lesion. Would this have a better outcome than cutting out the tumour, followed by radiotherapy and/or chemotherapy. We spent 45 minutes going over the pros and cons of each option, before seeing the patient on our ward round.

As the discussion ended, I turned to Mr Furlong.

"We should go on the ward round now, sir."

"Must we? This would all be so much fun without the patients."

However, off we went.

Halfway down the long hospital corridor another phalanx of doctors and registrars approached from the opposite direction. It was the neurology firm.

"Count them," Mr Furlong whispered to me.

I duly counted their number as they filed past.

"Twelve," I said, noting that that included a student or two.

"It's immoral," the boss pronounced. "They don't get many of their patients better. They should all be pensioned off with a silver spoon."

I saw what he meant. Those neurologists were great diagnosticians, but they didn't have a huge armoury of treatments available to them.

It was mid-October 1970. We joined up outside Doulton ward with the physios and students, and duly started our ward round.

At the bedside of a lady who was three days post-op after having a hip replacement, Mr Furlong turned to the physios to enquire after her mobilisation progress. Things were not progressing well, and the general consensus was that the patient should have been mobilising more quickly. Mr Furlong went to the patient's side, turned back the sheets and put out his arms to her, one hand going right behind her back. He gently lifted her to a standing position, steadied her, and he said, "Shall we dance, my dear?"

This was followed by other words of encouragement as she started to move across the floor away from her bed. I turned to glance at the physios, who all looked on in bemusement and disbelief. For three days they had failed to even get her out of bed.

This was an important moment for me, as I learned a lesson in patient management that could not be found in the pages of any textbook.

After Doulton, we went to the male surgical ward and the policeman with the sarcoma. Mr Furlong outlined our management plan of removing the tumour followed by radio/chemotherapy. Mr Furlong also explained that he would be on the next day's operating list.

In the same ward was David Bennett, a motorcycle police officer with a broken ankle. He too would be on the Friday list.

Fridays were always difficult for me. I had to do a round of the wards to ensure there were no immediate problems, and then be changed into my surgical gown and mask and be ready by 8.00am. The morning operating list was undertaken by a registrar and another consultant, and I assisted until lunchtime. Sandwiches were laid on in the surgeons' changing room, and I usually had a few moments to eat before starting the afternoon list with Mr Furlong. When he had finished the open surgical procedures, I would be left to do other jobs, such as changing plasters on children who had soaked theirs. These were often on the legs and hips of, for example, children with congenital hip dislocation. The children were anaesthetised for this procedure.

Late one Friday evening, at around 8.30pm, I was removing the damp plaster from an 18-month-old baby when the anaesthetist pointed out that he could see some blood. Sure enough, there was blood coming from just above the spot where a normal little toe would be. The baby had little toes that started from the upper part of the foot, and these are known as hammer toes. The problem was that I had inadvertently cut off the hammer toe from one of his feet. I removed the plaster in a different way

the other side. Another hammer toe. I checked the notes of the registrar who had originally put on the plaster, but there was no mention of a hammer toe. Devastated, I dressed the wound, put on a fresh plaster and, in the changing room, phoned Mr Furlong at home to explain what had happened.

"Thank you for telling me so quickly, and I can hear from your voice that you are naturally very distressed. In my early days as a registrar, I can remember six of my patients dying, and I know how it feels. Go to the hospital bar, have a couple of gins, and put them on my account. On Monday, I will talk to the parents, explain that, for this child, a hammer toe like his is not a good idea. One has been removed and, with their permission, we will remove the other when we next change the plaster."

I'm not sure that actually happened, but his positive support really helped me, and again, his handling of a worrying situation was fantastic.

I was asked out to lunch at the Athenaeum Club on 11 November by Henry Barcroft, the Professor of Physiology, and a Cambridge friend of my father's. Having checked with the boss, and arranged medical cover from another houseman, I set off for lunch. By now, I had acquired an Aston-Martin DB4 and, not having driven it for some time, I was eager to give it some welly. I managed to wind it up to 80mph down the Mall and, as I turned into St James's, there was a siren and flashing lights behind me. A traffic cop on his motorcycle stopped in front of me and ordered me to get out of the car.

"I had difficulty keeping up with you," he said, "You were possibly doing 100mph, and I must caution you."

He walked around the car and spotted the St Thomas' Hospital car park sticker.

"Do you work at St Thomas'?" he asked.

"Yes, officer, I am the orthopaedic house surgeon and, in fact, I am looking after one of your fellow officers, David Bennett."

"Are you really? He had a terrible accident. How is he doing?"

"We operated on his ankle two days ago, and he is making a good recovery, I am pleased to report. Perhaps you could pass this good news on to his other colleagues."

"Thank you. In the circumstances, you may go on your way, but do be more careful. Other officers may not take the same attitude, and you could find yourself losing your licence. Give David my best wishes for a speedy recovery."

I drove on to the Athenaeum for lunch. Among the lunch party was Mr "Pasty" Barrett, a gastro-intestinal surgeon who had described the ulcer at the bottom of the oesophagus, now known as Barrett's ulcer. After lunch, I resisted the temptation to wander upstairs to stroke the palms of the sleeping bishops. In any event, I had to return to Thomas's to check on my patients.

*

A couple of weeks later, Mr Furlong asked, "Will you please go to Sister Theatre and collect my surgical instruments. Then come assist me with some operations at King Edward VII Hospital for Officers, just off Harley Street. We will start the list at 8.30, but I would be grateful if you could get there earlier to give my instruments to the theatre sister to autoclave them before we start."

This was good news, because assisting with Mr Furlong's private lists, of which there were plenty, always meant a nice cheque to supplement my houseman's income.

I drove to the hospital and easily parked outside, as there were no parking restrictions or yellow lines in those days.

In the surgeons' changing room, I changed into my green surgical clothes, and went in search of the theatre sister to give her the surgical instruments. When I returned, there were two other people in the changing room. One introduced himself as Dr Beaver, the anaesthetist, and the other was Dr Adams, the GP of the first patient on the list. I was happily chatting to them when Mr Furlong appeared at the door.

"Ah, good morning, Beaver, I see you have met John."

He continued, looking at me,

"John, I saw your car outside, so I knew that you were already here. My instruments are with Sister Theatre?"

"Yes, sir."

"Is the patient in the anaesthetic room? Yes? Good, so Beaver will you take Dr Adams with you and put the old girl to sleep?"

As Mr Furlong put on the green surgical out-fit, he turned to me.

"It's not safe to let you out of St Thomas', dear boy. I come in here and find you swapping medical pleasantries with that old murderer."

"Sir?"

"That's Dr Bodkin Adams, and he will have come up from Brighton in the patient's chauffeur-driven Rolls-Royce to see me bump her off. But you are going to make sure I don't. Aren't you?"

Dr Bodkin Adams had been the subject of a famous murder trial, in which he was accused of overdosing some of his rich elderly patients, who had left him huge bequests in their wills. Between 1946 and 1956, 163 of his patients had died while in comas. At his trial, his defence lawyer overheard nurses on the train to Brighton, where Dr Adams practised as a GP, disclose some vital discrepancies in the prosecution's case. This information was

used to get him off the murder conviction, but he was struck off the medical register for four years. After he was reinstated, he was restricted in what he could prescribe. So, I was well acquainted with the notorious Dr Adams, and entertained by Mr Furlong's take on the story.

We scrubbed up, put on our surgical gloves and masks, and went into the operating theatre. The patient was already on the operating table, anaesthetised and with Dr Beaver seated at the head end of the table.

"Dr Adams," Mr Furlong asked, "will you sit on this chair behind me so you can watch proceedings from there?"

I was standing opposite Mr Furlong and we started the operation to open the hip joint area prior to inserting a prosthetic hip. As we proceeded, Mr Furlong severed a small artery, and blood spurted into the air. I rapidly put my finger on the artery to prevent further blood loss. The boss looked at me over his mask and raised his eyebrows, and looked upwards, behind his gold halfmoon specs. Recalling his earlier remark about my role in preventing the patient's demise, I grinned behind my mask, trying not to shake with laughter. When it was time to prepare the hip for the prosthetic cup, he paused before turning on the ream rotating cutting instrument that made an awful bone-crunching noise.

"What is it, dear boy?" he asked.

To which I replied, "Christians to the lions."

We tried this line out whenever there were other people in theatre with us and, on one occasion, someone fainted.

During operations, one of my tasks was to keep tabs on the amount of blood lost during the procedure to ascertain whether we needed to put up a bottle of blood to replace the loss. Swabs were weighed, vacuum bottles measured, and so on.

We always grouped and cross-matched the blood from patients who were undergoing bigger procedures, such as hip replacement. Fortunately, in Mr Furlong's hands, this was rarely needed. In the early 1970s, the Blood Transfusion Service was taking blood from donors in the same pint bottles they had been using for years. However, the hospital had graduated to a metric system, so my task was made all the more complicated by having to convert the millilitres or litres of blood loss to the pint bottles of replacement blood.

I was the only orthopaedic houseman, whereas all the other housemen in the hospital were in teams of two. This meant that they could take off alternate weekends. We had our own bedrooms in the hospital, and none were set up for married couples, so marrying before doing one's house job was discouraged. I cannot remember the specific rules related to inviting nurses into one's room but, whatever it was, that rule was broken and waived by the authorities.

Because I had no duty cover, I was deemed to be on duty 24 hours a day, seven days a week. During my time at St Thomas' the Junior Hospital Doctors' Association made some headway regarding overtime for the number of hours worked during a week. This caused alarm and consternation amongst senior staff when they realised that I would qualify for a salary that was in excess of that received by senior registrars. Some attempts were made to find cover to prevent this happening. However, cover could not be found and I received a hefty overtime bonus. Mind you, my colleagues on the medical wards often had to admit seriously ill patients presenting with heart attacks or strokes, who then died after a few days. Having signed the death certificate,

they would often be asked by the undertakers to complete part one of the cremation form. If a patient has requested a cremation in their will, a form has then to be signed by two doctors, one the treating doctor and the other an independent doctor who is not part of the treating team. This resulted in a cash payment from the undertakers. I can remember visiting a medical ward during visiting hour and seeing a colleague outside the ward, as the relatives trooped in, being handed a sheaf of ten-pound notes by an undertaker. We irreverently called this "ash cash", and it naturally slipped happily into the pockets of the recipients. Whether the relatives suspected that undertakers were bribing doctors to quickly dispatch their loved ones, I will never know.

One day, I managed to get someone to cover for me over lunch while I went to Sotheby's to look at an oil painting that I knew was coming up for sale in its next auction. I was stood looking at the picture, when I felt a presence behind me.

"Hello, dear boy, have you got your eye on something?" asked Mr Furlong.

Oh dear, caught out.

"Well, yes, sir. This portrait has been miscatalogued, and the keeper of the Queen's pictures, Sir Oliver Miller, has tipped my uncle off, and he suggests that I consider buying it. It is catalogued as being School of Lely, but Sir Oliver says that it is, in his opinion, by Sir Peter Lely himself."

"Very nice to have had such guidance. Good luck at the auction."

I made my way back to St Thomas', certain that I was going to be in terrible trouble for being absent from my watch. Many weeks later, as I was coming to the end of my stint as Mr Furlong's houseman, I had the courage to ask him about this incident.

"It never worried me, as I knew you would have everything under control," was his kind reply.

Unfortunately, others had noticed the Lely too, and I was outbid. However, there would be other opportunities in my art-buying career.

The boss and I were having our sandwiches in the theatre changing room.

"What do you intend to do once you have completed your pre-registration year?" he asked me.

"I am really enjoying orthopaedics and thought that I might specialise in this after doing my medical house job at St Helier." I was soon to be Dr John Harman's houseman at St Helier Hospital in Carshalton.

"Now listen to me," said the boss. "I don't think the Health Service is going to be a very nice place to work in the next few years. One of my first housemen now looks after more dukes and earls than any other GP in London and he's looking for a young man like you. Come to my Christmas party in the Street [Harley], and I'll introduce you to him."

I went to that drinks party and my career path was set out before me, as I now had an entry into a central London practice.

As it happens, the boss was right. By the end of the 1970s, the hospital unions were striking, at Charing Cross Hospital in particular, causing serious disruption to the working of the hospital. Patient care was compromised and it looked as though union interference would make working in the NHS an unhappy experience.

A week before Christmas, Sister Doulton sidled up to me with a smile on her face. This is unusual, I thought, but, by now, it was

too late in my tour of duty to carry out the boss's instructions to warm her up.

"I wonder whether you would wear your tutu on Christmas day and carve the turkey on the ward?" she asked.

I know what you are thinking. The doctor's a cross-dresser and can only now admit it. Wrong. I had taken part in the previous year's Christmas show in a skit where eight tall male medical students performed an impeccable ballet in tutus, with a short fellow student in a black outfit playing the male role. One by one, he tried and failed to lift us up, until we circled him in the middle of the stage and dropped him through a trap door. We continued dancing with straight faces, as there is nothing better than blokes in frocks on a stage. This became a skit we would carry on performing on old boys' night until we could no longer squeeze into our tutus. We always received an encore.

I duly agreed to get my tutu from the storeroom and appear on the ward at 12.00 to do the honours of carving the turkey.

After checking on patients on Christmas Day, I went to my room and put on my tutu. I looked in the mirror. Everything was in place – no ladders in the stockings, ballet shoes on correctly, and the blond wig combed and clipped into place. A touch of rouge on the cheeks and a dab of lipstick and I was away down the corridor towards Doulton ward. There were shouts of "Ooh la la" and catcalls from a few chums, and screams of laughter from others, as I passed. I need not have bothered with the rouge on the cheeks as, by now, my face was pink from all the attention.

Sister Doulton was delighted to see me, having kept my arrival in a tutu as her little secret from the staff nurses and the patients. There was delight from the patients as I pranced around

and then set about carving the turkey. The patients thoroughly enjoyed the spectacle of their doctor making a total fool of himself.

Sister then admitted me into her holy of holies, her office, which was normally out of bounds, forbidden territory. There, she had lined up gifts from grateful patients that she had squirrelled away over the past year. Bottles of all sorts, but mostly a profusion of bottles of sweet sherry.

I was duly offered a glass, and then a second, and a third. Sister was on a roll.

I was starting to feel very comfortable and grateful that my beeper had not gone off, when she told me that she had mentioned her houseman in a tutu to a number of other sisters who were now requesting my presence on their wards.

I dragged myself away from Doulton ward and Sister, who, by now, was beginning to look like Audrey Hepburn, and went to the next ward on my theatrical tour. In each ward, I made a visit to every patient for a handshake and a laugh, and then off to that Sister's office for more sweet sherry. After half a dozen wards, I could remember no more.

I woke in my room on Boxing Day. The tutu was on the chair; I was naked in bed and some colleague had kindly taken my beeper to answer any calls that came in. Fortunately, all had been quiet, and the latter part of this incident went undetected.

In addition to my job as the orthopaedic houseman, I had to cover plastic surgical patients and attend at some operations. The principal surgeon, Mr Dickie Battle, had an unusual attribute of not wearing surgical gloves when operating on outpatients. He washed his hands thoroughly, and maintained that gloves removed the sensitivity in his fingers, preventing him from

making the neatest scars possible. He explained that the main reason patients developed infections in wounds was due to poor surgical technique and blood being left in the wound. I do not remember any of his patients developing infections, their scars were neat and healed quickly, bearing out his modus operandi.

Towards the end of December, I was called to Casualty, where a man, who had been in a fight, potentially had broken bones in his arm. When I arrived, I was directed to a cubicle where I found an unkempt, unshaven rough-looking 40-year-old. An X-ray of his arm revealed that none of his bones were broken, but he had a nasty gash that needed suturing.

I collected the suturing kit, took off my watch, scrubbed up, and put on my surgical gloves and mask. Having dressed the wound, I went to clean up while the patient was joined by a gang of his friends. They helped him on with his coat, and they left. As I was leaving Casualty, it occurred to me that I had left my watch in the cubicle but, when I went to retrieve it, there was no sign of it, and it had not been handed in to the nurses. What a shame, it was a nice watch that had been given to me as a 21st birthday present.

The next day, I was called back to Casualty, where I was met by one of the gang who had been with the patient whose arm I had sutured the day before.

"Is this your watch, doc?" he asked.

He held out his hand, revealing my lost watch.

"Yes," I replied. "Where did you find it?"

"I'm what nicked your watch will not be nicking watches no more!"

I thanked him and asked for no further details. There is honour amongst thieves, and you do not nick watches from your

local hospital doctor, who has just stitched up a member of your gang.

Other colleagues told me of curious cases that they had to deal with in Casualty. One evening, the gynaecological houseman was called to see a woman, who was lying in a cubicle looking rather sheepish. It transpired that she had been out in her boyfriend's sportscar and they had been mucking around. She had impaled herself on the gearstick and the knob, having entered her lower regions, had loosened off and was now firmly lodged inside her. The houseman was easily able to remove the object, but struggled to contain his laughter behind his mask.

Sister Casualty kept a book into which we had to write up any accidents that had happened. Her intention was to write them up and publish them. This incident clearly warranted a mention, and Sister was not best pleased as it was not exactly the sort of thing she wanted in her book.

She was apoplectic with regard to another entry. A 48-year-old man presented to a colleague with a nasty wound on his penis. He explained that he had been getting a blowjob from the wife of a neighbour in Lambeth, when they heard the front door bang shut, as the woman's husband returned home unexpectedly. This caused her to bite down hard, wounding the poor man's willy. The wound was duly sutured, and the treating doctor could not resist accompanying the entry in Sister's precious book with a beautifully drawn and somewhat graphic illustration.

2

The medical houseman

In 1971, I continued my medical education as a houseman at St Helier Hospital in Carshalton, in south London, working as a house physician under Dr John Harman. He was a general medical physician and an excellent teacher, in the old school tradition.

"I see you have decided to write this patient up for propranolol," he said one day. "Could you please tell me all the side effects of this medication?"

"I am not really sure, but it is known to be very effective in lowering blood pressure," I replied.

"When you write up a medication for one of my patients, I will expect you to know all the side effects," he admonished.

The next day, I was taught another valuable lesson.

"You seem to have written this patient up for a multitude of tests. Could you please explain to me, based on the clinical symptoms, why you have chosen each test?"

"Actually, this is what we sometimes did in orthopaedics to make sure that we did not miss anything," I replied.

"You are not doing carpentry now," he remarked. "You are wasting NHS money with your blunderbuss approach. In the future, you must be able to justify all the tests that you have ordered".

He was an excellent teacher, and I, and the students, learned a great deal from him.

"Half of what I teach you today will be redundant by the time you retire. The only problem is that I don't know which half," was one of his many memorable aphorisms.

We were on a ward round with a student who had seen a patient and was now presenting the case. The symptoms did not fit any obvious pattern of a specific medical condition. Diagnostic blood and urine tests and X-rays were not much help. When we wrote up notes we used certain initials: CO = complained of, HPC = history of present complaint, FH = family history, MI = myocardial infarction (heart attack), CVA= cerebro-vascular accident (stroke), and so on. For 'diagnosis' we used a capital Greek D for delta.

Dr Harman listened to the student's presentation of the case, before saying, "Thank you for that, a good clear history, and useful diagnostic tests. So, what do you think is the diagnosis?"

"It would seem to be a clear case of GOK," the student replied.

"I see. And how have you come to that conclusion? And what does GOK stand for?"

"That is what you wrote in the notes at outpatients, sir."

"You will have to be much more senior before you can make that diagnosis," replied Mr Harman, "Because GOK stands for God Only Knows."

Mr Harman had two daughters, one of whom, Harriet, went on to become a front bench MP for the Labour Party.

I met him many years later at a medical dinner, and we caught up.

"Hello, Gayner," he said, "How are you getting on?"

"Fine thank you, sir," I replied. "I'm enjoying practice, and having more time with my patients in private practice really helps to build relationships. I cannot avoid noticing that your daughter Harriet is busy with the Labour Party. What do you make of it all?"

"Motor good, sensory poor," came his quick reply, as if describing a patient's neurological status. I had to agree with him.

I also learned about John Harman in the context of Dr Bodkin Adams's murder trial. Mr Harman had been brought in as an expert witness for the prosecution, whose lead barrister had questioned him on the effects of an overdose of certain drugs, including opioids. He had given a graphic description, during which he bobbed up and down in the witness box to great dramatic effect.

He was then cross-examined by the defence lawyer, whose approach was deceptively simple.

"Dr Harman, thank you for your theatrical display of the effects of opioids and other drugs, for the benefit of the members of the jury. Could you please tell me, how many of the cases that you have described have you actually seen yourself in the way you describe."

"None."

"No more questions."

By now, tennis had become an enjoyable distraction from my medical duties, and I became a member of The Queen's Club, where an hour on court would help me to forget, for a short while, some of the medical issues that I faced on a daily basis. Wimbledon was on my route back to London from Carshalton and, during my time as a medical houseman at St Helier, I had rather more free time on my hands and was able to attend the Lawn Tennis Championships on a number of occasions. I had managed to secure a press card for the Championships, so I always had a wonderful time on those days during the fortnight when I could escape from the hospital.

I had already decided to go into practice in central London. Ronnie Furlong's first houseman, David Hay, that GP to more dukes and earls than any other in London, had by now taken on Dr Robert Hancock. But another GP colleague of his, Dr John Creightmore, was also searching for a partner. David Hay had introduced us, and he agreed that I could join him, but not before gaining more hospital experience followed by general practice experience.

After my first houseman's appointment, I continued to work at St Helier's as a senior houseman in general medicine. At the same time, I set about joining in with the outpatients of a number of different specialities, including dermatology, rheumatology, venereology and paediatrics. The specialists that I approached were only too happy for me to sit in on their outpatient rounds, and my learning curve was steep.

Respiratory and cardiovascular disease were at the centre of the general medical team I worked with as a senior houseman. Cancer of the lung was one of the conditions that came our way. I worked with two consultants who handled severe cases in different ways, which, to some extent, reflected their personalities.

Following surgery, most of these patients were on chemotherapy and, if appropriate, radiotherapy. Early diagnosis, in the era before MRI and CT scans, was often not easy. One of the doctors would react badly if a patient, whom he had been monitoring with X-rays, developed cancer. He would remonstrate with himself, looking back at all the past X-rays, and be highly self-critical. This resulted in his throwing the chemotherapy book at the patient, even when it was obvious that the case was a lost cause. The other consultant, however, would accept the situation and balance the treatment, weighing up the potential benefit of continuing with full chemotherapy against the patient's remaining quality of life. I remember observing the different approaches of these two doctors and resolving to take on the patient management of the second doctor. I determined to be holistic, realistic of outcome, and supportive.

I suppose some of this is due to the way we are built. I can remember as a precocious 11-year-old being asked by a master at my prep school what I wanted to do when I grew up.

"I am going to be a doctor, sir," I told him confidently. "Because I am interested in the science and, at the same time, want to be involved with people."

A month earlier, my younger brother, Richard, and I had had biopsies taken from our arms. My mother also had a biopsy, so this was not about us as individuals. Rather, it was an exploration of why both my elder brother and younger sister had Down's

syndrome. There was no direct hereditary link in the family, and the doctors wanted to find out if they could explain why this had happened, and if my younger brother and I were carriers of a Down's syndrome gene. This clearly had the potential to have a considerable bearing on our future lives.

As women get older, their chances of having a Down's syndrome baby increase, and the numbers ramp up past the age of 40. My grandmother was 40 when my mother was born. Although my mother did not have Down's syndrome, 10% of her cells were triploid. Our DNA cells are normally lined up in pairs, but 10% of my mother's line-up had three strands, thus giving her a high possibility of having Down's children. My brother and I were both found to have typical two-strand genetic make-up.

I took a great interest in this, and started to look into the science behind it. This helped to formulate the career that I wanted to pursue. I also knew how much grief my mother had suffered, and her unjustified sense of responsibility for being the cause of her two Down's children.

As her first non-Down's child, I was very precious and spoiled rotten. I'm afraid that I became rather wild and uncontrollable, and those who know me well will say that my childhood helps to explain a lot of the way I have functioned ever since!

When I left St Helier Hospital, I moved to Canada and worked for a few months in practices in St John's, Newfoundland. This was my first experience of seeing patients with conditions that had not yet been seen by another doctor and who had not yet been sent to hospital outpatients or to casualty. At first, this was daunting but, gradually, I found my feet and enjoyed applying a diagnostic medical sieve to work out what was going on and in

which direction to refer the patients for tests and management.

I remember one particular patient who presented with a painful abdomen. He was clearly unwell, but did not immediately fit into any pattern that I had seen before. I made a presumptive diagnosis, rang the on-duty surgeon, and sent the patient to see him. He agreed that we should operate immediately, and I joined him in the operating theatre.

Having made a vertical incision and separated the abdominal muscles, the surgeon made a cut into the peritoneum to view the internal organs. The bladder looked normal, and there was nothing obviously amiss in the stomach or colon. But, as I had suspected when I contacted the surgeon, the patient had an empyema of the gallbladder. This was an infected gallbladder full of pus, which would likely have burst in the next 24 hours, resulting in an abdominal infection that would have been almost certainly fatal.

I was sitting in the practice office one day, when a fisherman from one of the many fishing boats in St John's harbour was brought in to see me. He was in considerable pain, and his right hand was wrapped in a makeshift cloth bandage. I removed the cloth to find that a 14-inch fishhook had penetrated the hand from the back through to the palm, with the huge barb on the palm side.

Now here was a condition that had not presented itself in Westminster or in the leafy glades of Surrey. I sought help from a local doctor, who I felt must have come across injuries such as this before. I first consulted with two younger GPs who were of no help. But I kept ringing around, and finally the answer came. I was to get a toolbox and extract a large pair of pliers that would be capable of cutting the fish hook in half. I should inject

anaesthetic around the area where the fishhook went through the hand and wait a couple of minutes for the anaesthetic to kick in. I was then to remove the barb from the rest of the hook using the pliers, and pull the hook out from the back of the hand. I achieved this, and the tough fisherman remained stoic throughout. The hand was bandaged, and he left, thanking me for my help. A week later, a large basket of fresh fish was brought to the practice, which I was happy to share with the partners.

I covered all the partners in that practice while they each took a two-week holiday. Other practices began to hear of this young and willing English 'trainee' GP, who would free them up to go on holiday. I was earning nice dollars and learning at the same time, so I had no plans for an exit date. But I was then given a useful piece of advice: "Make sure you leave Newfoundland before winter sets in."

Newfoundland has deep winters, with lots of snow. I took this advice and returned to London in the autumn.

3

The new London doctor

By 1973, I had joined Dr John Creightmore's practice near Sloane Square and started the process of building a practice of my own. I saw the patients that he could not fit into his busy day, and any new patients who signed up to the practice came to me as my patients. Things were hectic when he went on holiday, but those were the times when I got to meet his many devoted patients. He had a large practice of patients who lived in London during the week and travelled to the country at weekends. He also looked after the Royal Ballet School and graduates of the school who had become principals of the Royal Ballet.

For the first 18 months, I answered my own telephone and wrote my own referral letters, because I did not have a secretary. I would often accompany patients to consultations with specialists,

mostly in the Harley Street area. This gave me the opportunity to get to know the specialists to whom we referred patients. At these consultations, my post-graduate education continued as I sat at the feet of Gamaliel, i.e., London's top-flight doctors. My patients found it useful that I had heard everything that had been said, and they were able to discuss their cases with me afterwards, often during the taxi ride back to Sloane Square.

In April 1973, His Lordship's PA rang requesting a visit to a lady living off the King's Road. I was told she had an infection and she generally was not in good health. When I entered the house, I was met by a friendly woman having a cup of tea in the sitting room. She explained that her friend had leukaemia and any infection could be serious. I went upstairs, knocked on the bedroom door and entered. An attractive middle-aged woman was sitting up in bed, propped up with pillows. She told me that she was very grateful to his Lordship for arranging my visit, as her own doctor had not been able to visit her for at least a day. I took her history and details of her current infection, and told her that I wanted to examine her. When the sheets were pulled back, I found her to be wearing matching bra, knickers, suspender-belt and stockings. I made no comment, although this did rather take me by surprise. I recommended an antibiotic, and suggested that I give the prescription to her friend to collect for her.

Back downstairs, I was offered a cup of tea, which I gratefully received, and handed the prescription to her friend. Curiosity got the better of me and I mentioned the unusual bed clothing that the patient was wearing.

"You have not been told, I suppose," said her friend, "of the relationship between her and His Lordship."

"No," I replied. "This is my first time here, and I know no other details."

She went to a cupboard just off the sitting room and pulled out a red satin dress on a hanger.

"Most weekends, His Lordship's butler would put His Lordship's weekend bag and boots into the boot of his Bentley on Friday afternoon, so that he could drive from his house in Belgravia to the country. At least that is what his butler thought. In fact, he would drive a mile to this house, here, off the King's Road, park his car, let himself in and put on this satin dress."

"You cannot be serious."

"I am. Then, he would go upstairs, get on his knees, crawl to a chest of drawers in her bedroom, and take out of those drawers whatever she ordered him to."

"What do you mean?" I asked.

"In that drawer there were the paddles, whips and canes that she would use on him."

"Wow."

"He would have to stay in the dress all week-end. On Sunday afternoon he would take off his dress, put on his country tweeds and drive the mile back up the road to be greeted by his butler in Belgravia."

In June 1973, I drove down to Richmond to visit one of our patients. It was a lovely detached house with a driveway in front. A friendly young man let me in and showed me upstairs to the patient's bedroom. The patient was lying on a large and elegant four-poster bed, placed on a raised dais. After taking his history and examining him, I told him that the quickest way to relieve his condition was to give him an injection and that I would do

this into his bottom. He got out of bed, took off his pyjama bottoms, and I gave him his injection. With a little squeal, he did a magnificent jump and pirouette before putting his pyjama bottoms back on. Entertained by this movement, I said,

"After that, do you pay me, or do I pay you?"

The patient was Rudolf Nureyev, renowned for being the sexiest male dancer at Covent Garden, sometimes described as a pair of balls followed by a dancer. I had now joined the select group who had seen this description in the flesh.

We looked after the staff at the Spanish Embassy and were often invited to events in the embassy, an elegant building on one corner of Belgrave Square. The building featured lovely tapestries and beautiful antique chests and tables. The ambassador rang me one day and asked if I would make a visit to see an elderly VIP who was staying in London. It turned out to be the Duke of Barcelona, a charming and polite man, and the father of King Juan Carlos of Spain. After the medical bit, we had an interesting chat about life in Spain, and I am delighted to say he made a swift recovery to full health.

At that time, the Aga Khan was a regular visitor to England as he had horses in training here. He had married a beautiful English girl, Sally Croker-Poole, who now carried the title of the Begum Aga Khan. On a visit to France, they had invited me to stay at their house in the Île de Paris, adjacent to Notre-Dame. The Aga Khan's mother was a patient of the practice, and we had also seen other members of the family. In addition, we had a mutual friend, Charles Benson, the "Scout" racing tipster in the *Daily Express*. The family was extremely welcoming, but told me and my wife

that they had just received an invitation to the Elysée Palace for dinner with President Valéry Giscard D'Estaing. Unfortunately, there was no room for us at the Presidential Table, but we would be welcome to have dinner at the Aga Khan's house. Our food was served on the most beautiful plates and, before the food went onto mine, I could not resist the temptation to turn the plate over to see if my suspicions were correct. The plates were, as I suspected, eighteenth-century Chinese *Famille Rose* plates that would normally have been carefully displayed in a cabinet, given how extremely rare and valuable they were. At breakfast the next morning, I commented on this to the Aga Khan, admitting that I had turned his china over to check on it. He was delighted that I had noticed and taken such an interest, and he gave me an extended look at some of his other treasures, of which there were plenty. Things had gone wrong for him with the UK horseracing world, so he had begun to build his own racing establishment in Chantilly, and he took me to see it. This was going to be his French base, and he subsequently withdrew completely from training and maintaining his horses in the UK.

A few years later, I was on the phone to Sally, who confided in me that she was finding their marriage difficult. She told me that her husband was away at his place in Sardinia rather too often, where she suspected he was housed up with his girlfriend. Sally recounted that he had sent her a package to their Île de Paris house, and had then rung her.

"Darling, did you receive a present from me today?" he asked.

"Yes, it came this morning."

"I hope that you like the watch and, with every tick of the watch, my heart beats for you."

Her response was swift.

"It's a digital watch and digital watches don't tick." Then she slammed down the phone.

They divorced shortly afterwards, and both have since remarried.

A few years later, I was contacted and asked to visit Princess Joan Aly Khan, the mother of the Aga Khan. She had travelled to the South of France, and was staying at the Hotel du Cap, in Cap d'Antibes. Unfortunately, while there she had taken ill, and I was asked if I could go straight down that day. There was no problem getting a flight, as the Aga Khan's Gulf Stream private jet was already on its way to Farnborough airport to pick me up. I quickly packed a bag, which included my tennis clothes and a racket. I had asked my secretary to book the last court that night with the hotel tennis professional, as well as the first court the next morning. I was picked up from home and driven to the airport, where we drove straight to the plane. My passport checked on board and I was on my way.

When I arrived in France, my passport was checked as I disembarked the plane and I was driven from the plane directly to the Hotel du Cap. What a way to travel!

I did my medical duties, played some tennis and, the next day, flew back to London with the patient and her companion.

4

On a film set

"Snow, lights, sound, action."

I waited for John Hurt, who was playing Richard Rich, to appear on the 'snowy' path and, as he approached me, I pushed my tall axe forward. He then walked past me into Hampton Court to report on his spying activities to Orson Welles, who was playing Cardinal Wolsey.

"Cut," Fred Zinnemann, the director, shouted. And then, looking at me, he said, "Could you, on the next take, push your axe forward rather more slowly, not as you just did in the first take. It was a bit too modern-day 'military on parade', and I feel not in keeping with the sixteenth century."

As I waited for the next take, a unit assistant came forward, and my shoulders were sprayed with more synthetic snow. The

snowy path had been created with sacks of a salt-like substance that crunched as John Hurt ran down the path. The surrounding area was created using a foam machine, and the windows all had snowy spray on the lintels. At the top of the building, supported from behind by scaffolding, were two men with large sacks full of pellets of expanded polystyrene. As the action started, large fans were turned on to blow at the sacks, which were slowly opened, and the resulting flakes fell during the action.

"Take two. Snow, lights, sound, action."

John Hurt ran up the path, and I tried to be more mediaeval in the way I pushed my axe forward.

"Cut. Excellent, well done, that looked perfect," Fred said as he checked with his cameraman that the take had gone well from his point of view. He then added, "We will do one more take just to be certain."

This was back in June 1966, and we were on a backlot at Shepperton Studios. I had become a member of the Film Artistes' Association, which provided extras for feature films. On this particular day, I was reading a medical textbook during gaps in filming. At one point, Fred walked up behind me.

"Hello, what are you reading?" he asked.

"Well, sir, I'm actually a medical student, and I'm reading a physiology textbook."

"You must come and meet my wife," he said. "She read medicine and my father was also a doctor. What is your name, so I can properly introduce you to my wife?"

I was led forward to meet his wife, Renée, who was sitting in a director's chair with her name on the back. Fred motioned for me to take his chair. As Renée and I started to chat, he continued to set up the next take. She was charming, and asked

me about my background, and why I had chosen medicine as a career.

As a result of this meeting, I became 'teacher's pet' and was destined to play several different roles in *A Man for All Seasons*. Little did I realise at the time that this world would become a large part of my professional life in the years to come.

My next role in the film was as one of the King's courtiers, and we had to rehearse a dance scene for a week before it was ready to be filmed. In the scene, Sir Thomas More, played by Paul Scofield, walked down a corridor to have a meeting that would seal his fate. Psychologically, this was in total contrast to the jollification taking place amongst the dancing courtiers.

When I watched the completed film I remember noticing that our week's work passed in just a few seconds but, in creating this scene, Fred had achieved something special.

Before individual takes, Paul Scofield would pace up and down reciting his lines and measuring the distance he had to cover during the take. I watched, in awe of his intensity and concentration, and the way this helped him to focus on the emotion in the scene.

The next notable scene was the execution scene, with the scaffold on Tower Hill recreated on the backlot at Shepperton Studios.

Before his execution, Thomas More pardons and then tips the executioner, with the words, "Pray dispatch me swiftly."

He then turns to the Archbishop and says, "I die his Majesty's good servant, but God's first." Whereupon, the executioner lifts his axe and cuts off Sir Thomas More's head.

The scene was to be filmed in two parts, the first with the dialogue, culminating in More bending down and kneeling so his

head was lowered onto the execution block, and the executioner lifting his axe.

The second started with the camera focused on Scofield on the block, before switching to the executioner lifting the axe. In this second piece of action, while the camera switched from More's head on the block to the axe, Scofield was to shuffle back so that the axe would fall onto the executioner's block.

The action was to begin at 2pm. I was watching this sombre scene from next to the scaffold. It was a glorious June day, but Fred wanted it to be cloudy to fit the solemnity of the occasion. There was not a cloud in the sky. We waited. Now it was 3pm, and still no clouds. At 4pm, a small cloud appeared in the distance, moving in our direction. It was now that the union leader called out, "Tea." Normally, this signalled the start of a 20-minute break. But the production called for us to remain on set for another 15 minutes. At 4.15pm the cloud was just approaching the sun. "Everybody, tea," shouted the union official and, this time, we all broke for 20 minutes.

When we returned to the set, the cloud had vanished. By now, emotions were high and tempers were frayed. The union's action looked as though it was going to result in a wasted day. This was expensive, given the large crowd of actors and extras and a complicated scene that required cloud cover.

By 5.45pm a large cloud was on its way, and we had a few minutes left. However, the production might well have to call for more time, which meant overtime.

At last, we had cloud cover.

"Sound, action." The first part of the scene was now being shot, and nobody wanted to miss their mark or get their lines wrong. It was all very tense.

Scofield, on the scaffold, said his piece to the executioner, handed him a purse of coins, addressed the Archbishop, and put his head on the block.

"Cut," shouted the director But the executioner, his vision impaired by having only tiny slits in his black mask, was so nervous and anxious to do what he was told, that he started to drop his axe at speed towards the block.

Fred Zinnemann, the mildest of men, screamed, "STOP!"

In the years that followed, I was to spend time in and around film sets. I witnessed a number of accidents and was there to try to prevent others from happening. But I cannot remember a potential accident that could have had more dire consequences than the one I witnessed that day.

Throughout filming, there was a great deal of talk about the film being an Oscar candidate. In the end, it was nominated for eight Academy Awards, and won six, including Best Film, Best Director for Fred Zinnemann, and Best Actor for Paul Scofield. The cinema-going public never knew how close Paul had been to receiving his Oscar posthumously.

I was learning how the film industry worked and, as 'teacher's pet', had the opportunity to talk to the production team and ask lots of questions. And I was being paid for this unique education as a medical student.

I now had a theatrical agent who found me a few modelling jobs, and I had been cast in a television commercial for the *Golden Wonder-nut*, a chocolate biscuit. A few weeks after filming, my agent contacted me to say that, for some reason or other, the advertising agency had not paid my fee. Several of the other performers in the commercial were members of the actors' union, Equity. The union was now dealing with the non-payment issue,

and I should go to their offices in Covent Garden to see if they would also help me to recover my fee for the commercial. I duly made my way there, and was told that I could be included in their action against the advertising agency if I joined Equity. In those days, actors left drama school and had to do 52 weeks touring with a repertory company before they qualified for an Equity card. But here I was, paying a tenner and being made a member of Equity in an instant. I was now able to take small speaking parts in films, although, clearly, I didn't want to compromise my medical studies.

A year after working on *A Man for All Seasons*, I took part in the forgotten film, *The Jokers*, starring Michael Crawford and Oliver Reed. As part of the film schedule, I attended two parties. The second of these was called "Camilla's coming out party". The Camilla in question was Camilla Parker-Bowles, the future Duchess of Cornwall. This was a fun and lively party, with several of us ending up being thrown into the family swimming pool in the early hours of the morning.

One of the girls at this party was the very beautiful Lady Charlotte-Anne Curzon. She was a very good friend of mine and had been cast in the film. It was heart-breaking to see her being brought to tears after being mercilessly bullied by the director, Michael Winner – not untypical behaviour of his, as it turned out. I did not forget that incident and, years later, when I was working as a doctor in the film industry, I came across him and knew what to expect.

My studies continued, and I don't remember any feeling of drudgery in opening my medical textbooks. I found it all

fascinating, and every day brought a new condition to learn about. Student life played out on the campus of St Thomas' Hospital and the medical school building adjacent to the nurses' home. When the dean gave his inaugural talk, he told us that he had met Matron on the hospital corridor, and she had reminded him to tell us that she did not expect to see any of us on the second floor of the nurses' home.

I heard the chap next to me whisper, "So, that's where they are. Useful to know on day one."

Earlier, when a very pretty girl student in a short skirt walked in, the same student had mumbled, "We've five years of that. This is going to be fun." These comments were, I suppose, indicative that both of us had been in single-sex boarding schools since the age of eight.

Rugby formed an important part of medical student life in those days. I had been made aware of this at my interview for St Thomas'.

I travelled up to London by train for the interview and, at Windsor station, I went into the newsagent looking for an interesting magazine to read.

Ah, there's this month's copy of *Playboy*, I thought. That should fit the bill.

But maybe that wasn't such a good idea. What if they asked me during the interview, "What did you read on the way up here?"

So, I bought *Scientific American*.

Needless to say, the question did not arise in the interview.

I was interviewed by the dean, the Professor of Anatomy and the Professor of Physiology, who was a family friend.

Having perused my interests, the dean noted that I was secretary of the Magic Circle at school and that I put on performances in the school library for any friends who wanted to attend. He then asked, "Which current magician do you most admire and why?"

Good question, I thought. He is trying to see how I assess the various magicians who are popular right now.

"Johnny Hart, sir, is someone who I have watched and tried to follow," I replied. "He won the Young Magician of the Year competition two years ago, and what I love about his act is that it relies on a card manipulation routine without any gadgets or equipment. I am able to do some of this and it has taken hours of practice. But he is an absolute master."

The Professor of Anatomy, Dai Davies, was also president of the rugby club. He joined in the interrogation.

"I see that you are on your school's first 15."

"Yes, sir."

"Which position do you play in, boyo?" (I am not sure that he actually said "boyo", but he was very Welsh-sounding, and could well have done).

"I'm a second row forward," I replied.

"Rather slight for a second row forward," he went on.

"I'm 6ft 2in," I told him. "And so is the other second row forward in our team. We do well in the lineouts, and some people say we are the fastest second row forwards in school rugby."

"Very good, boyo," he said, as he took a pencil and seemed to fill in a gap on the rugby team-sheet in front of him. I had the impression that his approval of my candidature was crucial to the whole process.

The dean looked from left to right at his colleagues, who were gently nodding, and then added,

"We look forward to your coming to St Thomas', either as an undergraduate or later, if you choose to go to Oxford or Cambridge first."

I was sorted, provided I didn't mess up my A-levels.

One of the things that came out of my St Thomas' Hospital interview was that they recommended that I take a year off between leaving school and starting my medical studies. I took some of my gap year in Paris, where I enrolled at the Alliance Française to improve my French, and also found an art studio where I could pursue my interest in creating ceramic sculptures and more useful domestic items, such as plates and bowls, decorated with exotic designs.

One day, during a break in the classes at the Alliance Française, I was approached by two Italian brothers, who asked if I would like to earn some money by doing an evening job. They were going back to Italy for a week for family reasons and asked if I and another English friend would replace them until they returned. I agreed to meet them at 4.30pm for a coffee near to their job to meet the boss, and to see if he approved of us as suitable replacements for the week. We duly met up, and he took us to the side door of a large building. After we entered, he clocked on with his work card, which noted his time of arrival. There were others arriving for work, including some extremely pretty girls, who did not look like cleaners or secretaries. Down a corridor, there was a door to the right that led to the director's office. We knocked and entered and met the director, and I was able to practise my French while discussing the job requirements with him. It transpired that we were to be evening doormen, helping patrons in at the beginning of the evening show, and

making sure they left in an orderly fashion at the end.

We discussed the pay, which, to our student ears, seemed huge, and we agreed to work during the Italians' leave of absence. We were fitted with coats and hats, and the Italians then took us to the front of the building and showed us where we should stand and what we should do. They did not mention that we might get tipped, and my smart school friend turned a tip or two down on the first evening, until I told him to pocket the money from happy patrons. On our first evening, I noticed the 'not cleaners or secretaries' appearing from time to time in tight-fitting revealing outfits to have coffee in the staff canteen. That was my first paid employment, as a doorman at the Folies Bergère.

In September 2019, I went to an art fair and came across a poster for the Folies Bergère from 1965/6 for *La Nouvelle Revue de Hélène Martini*, and this reminded me of that week in Paris. I felt that I had to acquire the poster to hang by my desk. If I said that I recognised the girl in the poster it would be because they were all the same height and shape so that the chorus line had perfect symmetry.

5

A doctor to the stars

In May 1974, Doug McClure came to see me, having been referred by one of my friends. Doug was working on a small budget film, *The Land that Time Forgot* at Shepperton Studios. He had made his name playing Trampas in *The Virginian*, a cowboy TV series that had been hugely popular in the sixties. A good-looking and gentle man, he had started out as a truckdriver before being spotted by a talent agent, who suggested that he try his hand at acting. During our post-consultation discussion, it transpired that he enjoyed tennis, and had played in several celebrity charity pro-am events in America. We agreed that, once better, he would join me and a couple of friends for tennis at The Queen's Club. We played a few times and, after each game, Doug would insist on buying us drink after drink at the bar. He clearly had a thirst!

*

About six weeks after I first met Doug, I was contacted by the producer of *The Land that Time Forgot* to say that Doug had turned up at the studio and did not seem well enough to work. He had insisted that he did not want to see the studio doctor, and the only doctor he would see was his new tennis partner. This was early on in my practice career and I was not overly busy, so I drove down to Shepperton Studios armed with vials of multivitamins, and a vial of high dose vitamin B12. I knew Shepperton Studios, having spent time there in *A Man for All Seasons*. The security guards at the gate had been forewarned of my arrival and I was directed to the film's production offices. Once there, the producer, John Dark, filled me in on the situation. The morning had largely been a washout, as Doug was not his usual ebullient self. His action was below par, as he kept missing his mark and muddling his lines. John explained that this was very costly to the production, which was running on a tight budget and, if I deemed Doug too ill to continue in the afternoon, they might well have to make an insurance claim.

I was taken to see Doug, who was lying on a daybed in his dressing room with his eyes closed. As I entered, he opened his eyes, and a huge welcoming smile broke across his face. He made to get up, but I restrained him, drew up a chair and sat down next to him. After a moment or two, he explained that he had had quite a night of it and was only just recovering. I examined him to ensure that there was no other condition that needed looking into, such as a respiratory infection, and then suggested that I give him a restorative intravenous injection of vitamins. Once this was done, I decided to wait for a while to see how he responded. After an hour of gentle

chit-chat and encouragement, Doug's appearance took on a different complexion, and he suggested that we lunch together in the studio restaurant. This was exciting as, in my student days, a sandwich in the canteen or a packed lunch was my lot at Shepperton, and now I was joining the film-world execs and the film stars at lunch. Doug was keen to introduce me to people as we entered the dining room. First, we went to John Dark's table to report on Doug's progress. I told him that, in my view, Doug was ready to work immediately after lunch. John looked uncertain, but I added that Doug had asked me to stay to see him in action.

This clearly pleased John, since I could monitor the situation, and write a medical report that would help him if he had to make an insurance claim.

On the set, Doug insisted that I sit in his chair while he acted out the scenes that had not been completed that morning. The production had already prepared these scenes during the morning, so they didn't take too much time. After two hours, they moved on to the rest of the day's schedule. At the end of each take, Doug came over for a chat, and I told him how wonderful he was in the scene. He was clearly enjoying showing off to his doctor/tennis friend and, although I left the studios before filming ended, it was clear that they had caught up on most of the time lost during the morning.

Later, John Dark rang to thank me, and to say that he had been in touch with the insurers, who were delighted with the outcome. They had asked John for my contact details, since they had a proposal for me, and he hoped that I did not mind if they subsequently wanted to meet me.

*

A week later, I was at Pinewood Studios, near Iver in Buckinghamshire. I was there for a meeting and lunch with the insurance executives who had asked for my telephone number after the Doug McClure episode. The executives were from Ruben Sedgwick, a large insurance company that placed risks with underwriters all over the world, including Lloyds of London.

In the film industry, Ruben Sedgwick represented the Fireman's Fund Insurance Company, which insured the bulk of Hollywood movies, no matter where they were filmed.

They explained that every movie production takes out insurance cover in case of loss due to interruptions in filming. Such interruptions can be caused by an accident on set resulting in serious damage to the set or props, or wind and storm damage to an exterior set. There was also the risk of a scratch from the camera gate, which could result in the loss of an entire day's footage. But the risk that caused the greatest concern was if an actor or the director was unable to work due to accident or illness. Therefore, all principal artistes had to undergo pre-production cast insurance medicals. These medial forms were then faxed to the brokers, Ruben Sedgwick and to the underwriters in America, the Fireman's Fund. Any exclusions, such as a cardiovascular exclusion in an actor who had heart trouble, could then be explained to the production company, who nearly always tried to buy out the exclusion. They offered me a role in all of this which, if I agreed to take on, would result in me and the insurers' doctor in Hollywood discussing the risk potential of any pre-existing conditions. This was explained to me as I tucked into lamb chops in the studio dining room while trying to discreetly peruse the stars eating lunch at other tables round the room.

As lunch drew to a close, they asked me if I would be happy to be their nominated doctor for film medicals and, if so, would I be available if issues arose with an actor's subsequent availability due to illness or accident. The latter issue would be arranged through the loss adjustors, also working on behalf of the Fireman's Fund. They explained that their longstanding preferred doctor was retiring and, with this in mind, they had taken a great interest in my activities with Doug McClure. Little had I expected my tennis friendship with Doug was to create the sliding door that I was fortunate enough to now walk through.

Soon after, I started doing regular cast insurance medicals for the Fireman's Fund. I began to realise that these medicals were different in several ways to the few life insurance policy medicals that I had previously carried out. Life insurance looked at life expectancy, whereas a cast insurance medical looked at the risk of production having to be halted because of an actor's non-life-threatening medical condition. So, a history of back problems that might incapacitate an actor for a few days was a relevant factor, and this had to be assessed in the light of the role the actor was to play. If the action might in any way cause a fragile back to seize up, I had to point this out to the insurers. Similarly, a history of cold sores (herpes simplex) on the lips could well present problems if there were kissing scenes or close-ups. Medicals were often undertaken just before production started and, if an actor came in with any form of blemish on their face, or some temporary limb issue that resulted in a limp, the insurers had to be informed.

One of the biggest causes of conflict between the production company and the insurers was non-disclosure of a medical

condition that subsequently caused an interruption in filming. After a while, I started to retain copies of medicals that I had already undertaken, and to write in relevant history on the insurance form before I handed it over to the actor to fill in and sign. I had started to notice the ease with which conditions were 'forgotten', and the tendency for some actresses' ages to decrease each time they underwent a medical. Because of my practice of filling in pre-existing conditions, non-disclosure became very rare amongst those actors who came to me regularly for pre-production medicals. I started to build up files for a select few talented performers, as the work tended to go to this small group.

With so many young actors graduating from RADA, LAMDA and the Central School of Speech and Drama, for example, there did not seem to be enough work to provide employment for everyone. This was so different from the fortunate position of those of us who trained as doctors, who all had continuous work from the moment we qualified.

In late November 1977, I saw Robert Mitchum who was in the remake of Philip Marlowe's *The Big Sleep*. The production involved several car stunts, which always had the potential for unexpected outcomes.

One night-time scene involved driving an old Bentley down to the end of a jetty and crashing it into the sea. The stunt driver, Mark, vetted the sea-side location with the director, Michael Winner.

Everything looked fine, but Mark asked, "Can we do this at high tide because at low tide the drop will be much greater, which will increase the risk enormously because of the greater impact on landing."

Michael, puffing a large cigar, replied, "Oh yes, dear boy, that's no problem at all."

Two weeks later, on the day of the shoot, Mark duly arrived at the location, where Michael had had a brick wall built at the end of the jetty without telling him.

"Wait a minute, Mr Winner," Mark said. "Nobody said anything about a brick wall."

To which the director replied, "Well, you're a stuntman, aren't you? You get paid for this sort of thing. What's the problem, something wrong with your bum?"

Rather stupidly, Mark said, "Okay, yes, I'll go for it."

He got into the car, where he had an oxygen bottle with a demand valve so that, when he went underwater, he could sit in the car until it settled, and wait for the divers to come and fish him out. It was night, the car was going into the sea and, needless to say, Mr Winner waited until the tide was at its lowest to get the best effect of the car going "Splosh". Mark started the car and drove towards the wall at speed. A brick went straight through the windscreen, hit him in the face and knocked the demand valve out of his mouth. The car sank into the water. Mark had not taken account of the electric windows, which shorted out the moment he hit the water, so he was unable to open the windows to get out. As the car settled on the bottom, he floundered about trying to find his demand valve, which was complicated by the complete lack of visibility due to it being a night-shot.

Meanwhile, back on the jetty, everybody was saying, "Great shot". But there was no sign of Mark.

In the dark, the safety divers were struggling to locate the car.

The mud from the car hitting the sea floor clouded the water and, after 90 seconds, they still had not found Mark.

One of the camera crew turned to Mr Winner and said, "If he comes up in the next 60 seconds, give him a round of applause. If not, we'll break for supper."

Mark was retrieved, with only his pride wounded because, as a top stuntman, he had not questioned the creation of the wall and under pressure had agreed to go ahead with the stunt at low tide.

A year later, in November 1978, I was asked to go to Elstree Studios on behalf of the insurers to see, examine and report on Jack Nicholson who, as Jack Torrance, was playing the lead in Stanley Kubrick's psychological horror film *The Shining*. He was in all the action that day, and there was a strong possibility of an insurance claim.

The loss adjuster briefed me at some length before I departed for the studios. Filming had been going on for several months, the actors were becoming tired and tempers were rather frayed. Stanley Kubrick was a perfectionist when it came to actors meeting their mark on the ground, and most scenes required numerous takes. In addition, scripts were often altered on the day, so that lines learned overnight were rendered useless when it came to performing a scene. This was all very stressful, even for the calmest and most patient of actors. I was led to believe that Stanley had taken so long with this film that his original budget had already been stretched, and he might be looking at the insurers as a source to extend his budget.

Armed with this information, I was first taken to see the director, who informed me of his concerns and told me that most of the footage from that day would not be useable.

I then had a consultation with Jack Nicholson, treated him as

was required, touched base again with Stanley and then reported to the insurers.

Two weeks later, I was asked to visit Elstree Studios again, this time to see Shelley Duvall, who was playing Wendy Torrance, and who was also in many of the scenes. She was becoming increasingly fragile due to the many takes, script changes, and Stanley Kubrick's complaints about her acting technique. She was now at breaking point, and this had the potential to result in an insurance claim.

I spent some time talking to and examining Shelley and ensuring her that there was no physical reason for her condition. I agreed to keep in touch, as it was clear that this was not a problem that would go away. Filming had now been going on for nine months, five or six months longer than the schedule of most major films.

While on the set, I met up with Jack Nicholson again and checked that all was well.

I sought to sympathise with him, since he too was enduring this arduous shooting schedule.

His reply was classic Jack Nicholson.

"No problem, doc. I just have another joint and I'm cool."

A week later, Shelley rang me from her room at the Dorchester Hotel. Her situation had become even more desperate and she did not feel that she could cope with the coming week's filming. I visited her at the hotel and we talked at length. It transpired that, in addition to the schedule stress, she had another pressing problem. She was seeing Ringo Starr, who was living in Brussels and unable to return to the UK because of tax problems, and Stanley had forbidden her to fly out to see him. Stanley hated flying, and he extended his personal fear to his cast and crew.

Shelley had not seen her paramour for many months, and this situation was adding to her already low clinical state. No amount of support from me was going to overcome this. I decided to take a large punt. She was not involved in any scenes from the following Friday through to Tuesday. So, I suggested that she fly out to see her lover during that time, but not to discuss it with anyone in the production company. To give her the confidence to do this, I told her that, should Stanley find out, I would take the blame, and I would try to justify it as part of my management of her health. In the event, her visit abroad went undetected and she was able to continue working without any interruption to filming. We continued to talk from time to time and I was sad when she went back to Hollywood, as we got to know each other quite well.

In January 1979, John Cleese asked me about *rigor mortis*, and how long it would take to set in. He was writing "The kipper and the corpse" episode of *Fawlty Towers*, in which he goes into the room of a hotel guest who has died and the kipper on his breakfast plate has to be disposed of. He kindly invited me to the recording of the episode, where I found myself sitting next to Tim Brooke-Taylor, an engaging companion to chat to while sets were being moved around.

Andrew Sacks, and his part as Manuel, has entered my vernacular. I am often asked, innocently or not, about what is medically wrong with so and so. My stock reply is, "I'm Manuel from Barcelona, I know nothing." Andrew sustained nasty burns from a fire stunt during the filming of "The Germans" episode, and a faulty prop used by John Cleese to hit him over the head had also given him severe headaches. Manuel was always going

to end up on the losing side, I suppose. But Andrew Sacks was charming, and belittled his role in the series, despite the fact that he was a critical component of its success.

6

Superman

In January 1980, I was consulted about problems that had just occurred with Jack O'Halloran, who was playing the character Non, the mute and menacing member of the trio of Kryptonian villains in *Superman II*.

The previous week, he had been engaged in flying sequences at Pinewood Studios, and he recounted the scene to me. In order to 'fly', he had been strapped into a fibreglass body mould, which was then attached to a pole. The pole, in turn, was attached to a machine which allowed the technicians to manipulate his position 'in the sky'. Jack recounted how the scene had played out, after he had been hoisted up in the back mould.

"Jack, all okay up there," the assistant director asked.

"Yeah, slightly uncomfortable in my lower back," he replied.

"Right. We are setting up the lighting now, and getting Christopher Reeve in place for the fight sequence."

Twenty minutes passed. Jack then said, "The pain in my back is worse, and I have a tingling in my left foot."

"Nearly ready, Jack. Christopher will be in place soon."

Another 30 minutes passed.

"I have a pain right down my leg now."

"We are just about to start filming and we are about to start the wind machine so your cape will flap, and it will be a little bit cold. Hang in there, Jack."

"Great take, Jack. We are about to go again."

"I cannot feel my left foot at all now."

By the time he came down, two hours later, he had developed a slipped disc in his lumbar spine.

A week later, with a neurosurgical colleague, John Currie, I visited Jack at his home. We made the diagnosis of lumbar 4/5 prolapsed intervertebral disc and recommended bed rest in the first instance. Jack was keen to see his American doctors and continue his treatment in the US. It was arranged that, on 10 January, he would fly by Concorde to JFK airport and, from there, fly on to Boston in a Learjet equipped with a bed.

On the same day that I visited Jack at home, I was separately consulted by Sarah Douglas, who was playing Ursa, Zod's second in command, and another of the three villains. She too had developed an acute strain in her upper and lower back following filming in the fibreglass moulds. She said that she felt nobody was paying much attention to her problems. I told her I was concerned that the moulds that had been made for her and Jack O'Halloran had been made without medical supervision, and

with no thought to the anatomy and physiology of lying down.

On 11 January, I visited Pinewood Studios to inspect the moulds. These were initially created for an actor 'flying' on their front and were made by lying the actor on his or her back on the ground, placing some muslin from the upper chest to above the knee and applying fibreglass over the muslin. This had not caused the actors too much distress. However, if you reversed the process with the actor on his or her back, for a fight scene, for example, a problem emerged.

A different mould has to be created for this, and by making them in the same way as the front of the body flying moulds, a major problem was created. When we lie on the ground on our backs, the weight is taken in the middle by the buttocks flattening and the pelvic bones being the pressure point. But shaping the mould over the back, buttock and upper leg meant that a huge part of the weight was taken over the lumbar spine and, in a heavy 7ft-tall man with a tendency towards slipped discs, such as Jack O'Halloran, undue pressure was placed on the spine.

When I reported on the creation of the back moulds to the neurosurgeon John Currie, he told me of a vaguely similar situation during the Second World War, when rear gunners, known as Tail-end-Charlies, were given curved seats that fitted the bottom because the engineers thought this would be more comfortable during long flights. They, too, lost the sensation in their feet, and sometimes struggled to walk after a mission and had to be lifted out of their turrets. Fortunately, being fit young men, the sensation and muscle power quickly returned.

Sarah had to wear a flimsy garment in her scenes and she was given no warm-up period. In one scene, she even had a man on her back. In addition, three days prior to her problem in the mould

she had had to throw a bus across a street with people inside. This was a full size, but lightweight, gravity-assisted model, but the bus became slightly stuck, and the force she exerted to lift it was greater than expected, and she felt a significant pull on her back.

I advised inserting padding into the buttock area of the back mould so that it would correspond to the situation when the buttocks are flattened when lying flat. I also recommended introducing warm-up exercises, and restricting the length of time the actors spent in the moulds.

Sarah improved with physiotherapy, but Jack required surgery which took place once filming was complete.

Litigation was likely, particularly for Jack who had been scheduled to start work on another film, *The Informer*, as soon as filming on *Superman II* ended.

A writ was issued in the High Court of Justice, Queen's Bench Division on 2 April 1980 between Anastasia Production Company Incorporated (first plaintiff) and Jack O'Halloran (second plaintiff) and Dovemead Limited (defendants). Anastasia Production was Jack's offshore company that was contracted to provide services to Dovemead, the film's production company. This was for damages for the loss of work on *The Informer*, and compensation for pain and distress.

Dovemead presented a letter dated 15 January 1980, in which a doctor maintained that Jack had pre-existing and longstanding back disease with considerable degenerative changes throughout his lumbar spine, with narrowing of the L3/4 disc. It went on, "The primary cause is not due to any physical activity of recent occurrence."

Clearly this had to be rebuffed, and I provided neurosurgeons who concurred with my view that the creation of the back mould,

and the length of time he had been in it, had played a major part in Jack's classic symptoms of lower back distress and ultimately, a slipped disc.

Jack received no direct compensation from this litigation!

Dovemead's legal team insisted that Jack was not their employee, as they had contracted Anastasia Production for the services of its employee Jack O'Halloran, and Anastasia Production should have its own employee injury liability cover. Anastasia was a tax-efficient offshore creation of Jack's Hollywood tax advisers, who had omitted to take out liability insurance for their principal employee.

There was a sequel to this sad and, seemingly, unfair situation some years later. In August 1986, I received a letter from lawyers acting on behalf of Dovemead, asking for a copy of my records. The letter informed me that considerable sums were at stake. Permission was granted from all parties concerned, and I duly supplied the necessary documentation. I was then informed that I might be required in court on 15 October.

Jack O'Halloran's case for negligence, rather than the earlier one relating to employee liability, was settled out of court for £100,000 two weeks prior to coming to court. This sum was considerably less than I had felt he might, indeed should, have received.

On 6 October, I received a letter from the solicitors acting on behalf of Dovemead.

Dear Dr Gayner,

Jack O'Halloran Superman II

I attach my firm's cheque in settlement of your consultation fee. You will be glad to know that your estimate of the settlement damages was luckily over the top, but then with "Superman" as one of my witnesses I was bound to win, or does it only happen in the movies?

Yours sincerely

Christopher Reeve was 'super' fit and suffered none of the ill effects from the flying sequences that Jack and Sarah suffered. Besides, it was his face that was important, so he was in the correctly made front mould.

There were other accidents during the production, one of which involved Sarah Douglas.

In a scene set in the White House, Sarah grabs a Secret Service officer by the neck and throws him over her shoulder. This was filmed in two shots. In the first, the camera was positioned behind the stuntman, a 32-year-old ex-paratrooper called Jim Dowdall. He stood on a Teeterboard, a rocking thing of the type you see at the circus. He stood at one end, with two heavyweight chaps at the other. He had to bump up and go over Sarah's head. This went according to plan. In the second shot, he was to fly through the air and hit another man standing against a window, before going out through the window. The camera was positioned to face the man standing by the window. Jim was to jump off a rostrum onto a small trampoline, over the top of the camera and hit the man. Unfortunately, the trampoline was not secured to the floor so, when Jim hit it, he got the required height, but the trampoline slipped backwards, causing him go over the camera but fall well short of his target.

The man he was aimed at could not move forward in time to break his fall, and Jim fell onto his head and sustained a serious neck injury.

7

The eighties

In the middle of January 1980, I flew to Budapest to see Lesley-Anne Down, who was there filming the Orion Pictures production, *Sphinx*. She had been unwell for three or four days and this had delayed filming. The insurers wanted a first-hand opinion of what exactly was going on.

The production company, Hungarofilm, was the first Eastern Bloc film company to become accessible to overseas productions. This was attractive, as production costs were considerably lower than for films made in the West. Naturally, the infrastructure and back-up were creaky, and the fax machine in the production office was guarded for its life, being a rare commodity indeed.

Lesley-Anne Down's career had kicked off after she played Georgina Worsley in the ITV series *Upstairs, Downstairs*. She had

been in a number of successful films, including *The Pink Panther Strikes Again* with Peter Sellers in 1976, and *A Little Night of Music* opposite Elizabeth Taylor and Diana Rigg in 1977.

She was a star, and a very beautiful one at that. I attended to her in her hotel room, accompanied by the local doctor who had been taking care of her. We went over the history, and reviewed the investigations that the local doctor had arranged. I felt that the production company was putting her under some pressure and it did not know how to best handle the situation. I assured her that I would give the production company firm instructions about how she should be looked after from then on.

I agreed to stay with her for two days, to be with her while she recommenced filming and ensure that my instructions were being followed.

I had decided that, in dealing with interruptions due to illness or accident, my priority was to ensure the safety and well-being of the actor. Of course, 'the show must go on' and the main concern of the insurers, on whose behalf I was acting, was to keep losses to a minimum. But I had begun to gain the insurers' confidence to allow me to handle these situations my way, and by giving the actors the confidence to get back to work, the insurers would be better off in the end.

At the same time, there were other parties with vested interests – the actor's own doctor and agent, the production company and its investors, and an entity known as completion bond insurance. If a film was going way over budget, and there was no further funding available, the production company could call on completion bond insurers to finance completion of the film. This was not a happy situation, since it meant a reduction in

the number of takes and putting greater pressure on the director, who was no longer in control of each day's filming. These insurers then took all box-office receipts until their funding was recovered.

While on the set with Lesley-Anne, I was taken aside by the producer to discuss another delicate matter. The film contained some riding scenes and Leslie-Anne was due to take riding lessons in preparation for this. Unfortunately, she had had a nasty fall from a horse when she was 17 and was very apprehensive about riding again. I shared my opinion on the dangers of riding scenes with actors who were not regular riders. This resulted in the production cutting her riding sequences, and so removing the risk of Lesley-Anne sustaining an injury.

Following my visit, filming continued without further delay to the schedule. The film's running costs were $70,000 a day and, in total, it cost $14 million to make. However, it took only $2 million at the box-office. It bombed!

In early February, I made a call to Warren Beatty at the home he was renting in London while he wrote, produced, directed and acted in a film that was provisionally called *The John Reed and Louise Bryant Story*, but which would eventually be called *Reds*. This had been a passion project of his for many years. I saw a fair amount of him during set-up and filming, and we developed quite a friendship. One day, I mentioned to Jack O'Halloran that Warren had invited me to stay with him in Los Angeles, and I asked Jack whether I should take my wife.

He gave me a sideways look and said, "John, when you go to a banquet, you don't take a sandwich."

*

I started to look after Peter Sellers, who spent much of his time in a large suite at the Dorchester Hotel, although he also had a base in Switzerland, and an office in Pembroke Place, London W8. I always gave myself plenty of time for these visits, because after dealing with whatever problem he had, he always liked to talk. In truth, one of the reasons I enjoyed my practice so much was the greater amount of time I got to spend with my patients. I occasionally spent an hour and a half with Peter. He struggled with a number of emotional issues which, at that time, mainly revolved around his failed marriage to Lynne Fredericks. He also had serious cardiac trouble, which had required a number of hospital admissions in the past.

On 6 May, I went to visit Peter, who wanted to charter a yacht in the Mediterranean from 25 May to 8 June. I assured him that there was no reason not to do so. In fact, it should be a fun trip, I told him, and jokingly suggested that he should take his doctor with him!

On 23 July, I made an emergency visit to Peter at the Dorchester. He was cyanosed (blue) due to lack of adequate blood flow and oxygenation, and had clearly suffered another heart attack.

I arranged for an ambulance to take him to the Middlesex Hospital, where he sadly died the next day. Face to face, I had seen the man behind the comic genius, and I mourned for the loss of a patient's life, and the fact that he would no longer be around to give the world such great pleasure from his performances.

Warren Beatty was now filming *Reds* in Seville and in early June he asked me to go there to deal with one or two medical issues that had the potential to hold up production.

The day after I arrived was a Spanish national holiday, so the production had use of the Alcázar Palace, which was closed to the public for the day. This magnificent palace, with a history that dates back to the tenth century, was to be the site of a large gathering of 600 Cossacks. Warren Beatty was playing the lead role of John Reed, an American sympathetic to the Russian Revolution. In addition to acting, he was dealing with many other aspects of the production.

Jerzy Kosinski played the role of Grigory Zinoviev, and it transpired that Jerzy had written the book *Being There*, which was made into the film which turned out to be Peter Sellers' last. Jerzy and I chatted about Peter, unaware that, in five weeks, Peter would be dead.

I attended to my medical duties in the Alcázar Palace until 12.30, when filming stopped for lunch.

In the cool shade inside the beautiful building, a long table had been laid up with a white tablecloth, cutlery, and glasses for red and white wine and water, and we sat down to a delicious three-course meal. From time to time, a rattled assistant director would come to talk to Warren, who would then leave us to deal with some urgent crowd situation. It transpired that the local catering company, contracted to bring lunch for the 600 extras, had not turned up. It was extremely hot, and the 600 Cossacks were in thick costumes. They had nothing to drink and were hungry. By 2pm the food had still not arrived. It transpired that the caterers had left for the Alcázar at 11am, only to stop and sell the food to tourists, before returning to their base to replenish their stock for the extras.

Meanwhile, the scene began to resemble the Bolshevik Revolution, with the principal actors, doctor, and senior members

of the production team sitting down to a luxury lunch while the revolutionaries were gathering at our door. They had guns and sabres and, by now, were threatening to storm the interior of the Alcázar. Fortunately, the caterers arrived soon after, but it was a nasty scenario in which the drama of the film threatened to play itself out in real life.

A couple of days before Christmas 1980, Fred Zinneman came to see me. This was very exciting for the once medical student who had been an extra in his film *A Man for All Seasons*. He was putting together the cast and crew for a film which, at that time, was called *Maiden, Maiden*, but which would eventually be released as *Five Days One Summer*. He was, as always, immaculately dressed in a tweed jacket and tie and grey trousers, along with Gucci shoes with their trademark buckle. He asked how my career had progressed since we were together on the set of *A Man for All Seasons*, and we got onto the subject of psychiatry and, specifically, conversional states. His films often had psychological and emotional dimensions, and the subject interested him. At the time, a world authority on conversional states was Dr William Sargant, a psychiatrist at St Thomas' Hospital. He had written the book *Battle for the Mind*, which explored how people could be put into conversional states by preachers, political leaders such as Hitler, and tribal rhythmic dancing. The book also described the post-traumatic stress suffered by soldiers. I had a copy of Dr Sargant's book in my bookcase at the practice, which I loaned to Fred.

On 22 August 1981, I flew to Pontresina, a high ski resort in Switzerland. This was the location for Fred Zinnemann's *Five Days One Summer*, which starred Sean Connery, the American

actress, Betsy Brantley, and a French actor, Lambert Wilson. Lambert had developed a facial blemish on his right cheek. He had been seen a week or so earlier by a local dermatologist, who had given him some treatment and had said there was no question of him acting on the glacier for the time being. I was asked to monitor the situation, since he was urgently needed for filming on pinnacles above the glacier, to which cast and crew had to be taken by helicopter. I changed his treatment, adding in a sun-barrier cream.

That evening, the helicopters returned to the village. The first carried the props and camera equipment, and the second had been used to pick up crew members who were located on a different peak. On their way to this other peak, the helicopter crew had noticed legs with boots on, poking out of the snow. The props team had a number of these, for the avalanche scenes in the film. When the helicopter landed back at base, the pilot went to the props department and suggested that some 'legs' had been left on location up on the glacier. Props, having checked their stock, were adamant that they had all their 'legs'. Panic now ensued, as the production crew called everyone who had work on the glacier that day.

Unfortunately, they were unable to track down every member of the film crew, so the situation was reported to the town rescue team. The last of the two helicopters took off with a local search team and tracker dogs. After circling the mountain peaks, they located the legs in the snow, landed the helicopters and the search team precariously worked their way towards them. There, they extracted a frozen body from the snow, brought it to the helicopter, and flew it down to the valley. Once in the village, the body was examined. It was not a crew member. From the

identity cards and old currency in the victim's pockets, he was quickly identified as a Swiss policeman who had gone missing on a walking trip in 1919. His body had been well preserved in the ice, and had become visible only because the winter covering of deep snow had melted in the summer and, other than for the making of this film, helicopters would have had no reason to fly over that particular mountain location.

After all the tension, we ate dinner, followed by a screening of one of Fred's first films, *High Noon*, made in 1951. It stars Gary Cooper as a small-town marshal in New Mexico Territory, and Grace Kelly as his new wife. The marshal had sent a vicious outlaw to jail, and the outlaw, now released, is coming into town on the noon train to exact revenge. This scene at noon is, therefore, the moment of truth.

Fred explained to us that the man who had directed many of the earlier scenes had been fired by the producers because they felt the film was much too slow. Fred had carefully watched the footage that was already in the can and began to realise that he could capitalise on the slowness by making it a defining feature of the film. He introduced the railway station clock images, and the iconic shots of Gary Cooper looking at his watch as he and others await the arrival of the baddies on the train. This device helped to crank up the tension and, aided by the music, kept the audience in a state of suspense. The film was nominated for seven Academy Awards, and won four. Ned Washington's song, 'The Ballad of High Noon' (better known as 'Do Not Forsake Me, Oh My Darlin'') won in the Best Original Song category that year.

In February 1981, I was asked to see Roger Moore, who was playing James Bond in *For Your Eyes Only*. A few days earlier, he

had been in a fight sequence in Cortina that involved throwing himself across some ice and rolling over at the same time. There had been three satisfactory takes but, on a fourth, he fell badly on his left shoulder. The production company was anxious to complete filming in Cortina, so they arranged for the joint to be injected with anaesthetic so that he could continue to perform. On his return to London, he saw me with his shoulder strapped and in a sling. My examination revealed a limitation of movement, but X-rays revealed that there was no fracture. I arranged for physiotherapy to help him recover movement as the pain settled and, fortunately, only minimal time was lost on the production.

I saw Roger Moore again in December 1984, while he was at Pinewood filming *A View to a Kill*. One scene involved a sequence with a chair, which caught his left index finger, causing a deep laceration. The wound required no more than suturing, but it was, nonetheless, yet another film-set accident that needed to be recorded. Fortunately, filming proceeded without major problems.

In April 1981, I went to see a 37-year-old actor, Ben Kingsley, who was playing the title role in the Richard Attenborough film, *Gandhi*. While filming in Bombay, Ben had developed a pain around his eyes. He had been required to wear heavy contact lenses for three days during filming, and I thought this might be the cause of his discomfort. After a day or two without the lenses, the pain had gone away.

Contact lenses were yet another filming hazard to add to my list, and I had met another actor who was to win an Academy Award for his extraordinary performance.

*

In March 1982, Catherine Deneuve was in London and strained her back prior to starting filming *The Hunger*. I arranged to have her treated by an osteopath, so that she could start filming at the commencement of principal photography. I had previously seen Deborah Kerr and, in my opinion, she, Catherine and Nanette Newman are the sort of film stars that are a rarity these days. Those women were classically beautiful, elegant and perfectly dressed.

The osteopath was not keen on her starting work on the due date, but Catherine was having none of it and insisted on working straight away.

"The show must go on," she said

She was the consummate professional.

At the end of that month, I flew to Yugoslavia, and was driven to Opatija, in Croatia, to see Bess Armstrong, who was working on the film *High Road to China*. Tom Selleck, who had made his name in the TV show *Magnum*, had been cast in his first feature film. There were extensive exterior shots, with dust and smoke swirling around much of the time. Bess had developed a conjunctival reaction in her eye to the smoke, making work difficult for her. I had initially supervised treatment from the UK, and had then flown to the location to help get her back to work. She wasn't doing close-up work in many of the scenes, so make-up around the eyes and eye liner could be avoided. On one of the mountain locations, we could even justify her wearing goggles, such as those that pilots wear in open cockpit aircraft.

However, something much more serious took place before I arrived. On a particularly windy day, a helicopter was being used to film some of the action from the air. As I understand

it, the helicopter was blown into an overhead cable, causing the helicopter to crash and resulting in the loss of life of those on board.

Another tragic helicopter accident was to happen in July of that year, on the set of *Twilight Zone: The Movie*, directed by John Landis. During the filming of one scene, a helicopter went out of control, killing actor Vic Morrow and two child actors. All three were on the ground and caught under the helicopter when it crashed.

There was a view that this might have been caused by the detonation of debris-laden, high-temperature special-effects explosions in huts that were too close to the low-flying helicopter, leading to foreign object damage to one of the rotor blades. John Landis insisted that they had not been blowing up huts at the time, so there was no debris to hit the tail rotor of the helicopter. An examination by the FBI crime lab concluded that the tail rotor had delaminated, causing the pilot to lose control.

John Landis's next film was the comedy classic *Trading Places*, starring Dan Ackroyd and Eddie Murphy. As you might expect, the helicopter accident and resulting court case were extremely distressing for him. As a result, he left America and moved to London and did not work again for some time.

Helicopters, then, joined car stunts in my experience of extremely dangerous activities on film locations.

Meanwhile, back in London, in July 1982, the filming of *Superman III* was progressing at Pinewood Studios. I was on the set one day when the lunch break was called. All of the actors left the set, except for Gene Hackman, who asked two other actors

who were in a scene with him to wait back too so they could walk through their action for the first scene to be filmed in the afternoon. They did this several times and Gene seemed to be counting and memorising the number of steps, so that when filming began, he would be fully conversant with the walking and could focus fully on the performance. It was a remarkable insight into this highly professional and wonderful actor.

Andie MacDowell was playing Jane in *Greystoke: The Legend of Tarzan, Lord of the Apes*, and my main involvement in the film occurred around Easter 1983.

The director, Hugh Hudson, had directed *Chariots of Fire* to huge critical and commercial success and it was nominated for seven Academy Awards and won four. The producer, David Puttnam, had won the award for Best Picture.

Filming on *Greystoke* had started to fall badly behind schedule, and David Puttnam withdrew as producer, to concentrate on another of his productions, *The Killing Fields*. I wonder if this withdrawal was, to some extent, tactical, as having worked with Hugh Hudson before, he knew how difficult it was to keep control of Hugh's extra shots and multiple takes.

An important scene was to be filmed in the Natural History Museum. In the scene, the hero, Tarzan (although he is not named as such in the film), finds an old ape friend from the jungle who has been locked in a cage and releases him.

As with all places normally open to the public, the production company had to secure the space on a public holiday to ensure unrestricted and uninterrupted access.

This had been arranged for Easter Monday. But a problem arose. Tarzan's old ape friend, Greybeard, was to be played by

the specialist animal movement actor, Peter Elliott, and ten days before filming this scene, Peter had contracted chicken pox. I had been asked to see him, and to advise on the likelihood of his getting into the ape costume ten days after he had fallen ill. Peter was recovering well and, after eight days, the vesicles had crusted over, which was a normal and satisfactory recovery. I gave the go-ahead for filming to take place. This was a relief to the production, as they had already called in the completion bond insurers in the event that the budget for the film was exceeded. The cast insurers were interested as well, and were on the line for reshooting the day again, particularly if Peter broke down.

I had been asked to be on the film set to ensure that Peter came to no harm and I was on hand first thing in the morning. Hugh Hudson was immediately on my back, concerned that his other actors could catch chicken pox, leading to further problems. He also expressed doubts about the damage to Peter's health. I reassured him on both these points.

When Peter's old ape costume was produced, I was struck by art 'aping' real life (sorry, I couldn't resist). The costume had scattered sores on thinning grey ape hair, which looked uncannily like Peter's healing chicken pox. I had asked for space to be made available to him away from the rest of the cast and crew, in case there was even an outside chance that he was still infectious. Moving in this heavy thick ape outfit made him very hot very quickly, so I got my hands on a large fan and, at the end of every take, we would open the outfit and blow cold air all over him, keeping well away from everyone else on set.

Hugh did not spare Peter in the number of takes he required and, as the day wore on, he appeared to be looking for another day's filming at this location. Both insurers had a vested interest

in ensuring that the necessary footage was secured in one day, given how difficult it was to book the Natural History Museum. The completion bond insurers, in particular, had the clout to speed things up and, as a result, they ensured that all the necessary filming was completed. Peter was being pushed extra hard, but he did what was necessary and came to no harm. What a marvellous ape he made and, later, it gave me much pleasure to watch his performance in the film, knowing the hard work that had gone into it.

In December 1982, Kim Basinger developed an eye infection while filming the latest Bond offering, *Never Say Never Again*. While it was not serious, it threatened to interrupt filming because she had close-ups in a dancing scene, crying and kissing Sean Connery, who was back in the role of James Bond. On the day that she was urgently needed on set, the eye itself looked fine, but my concern was the slight eyelid swelling that might be an issue for close-up work. Fortunately, this proved not to be a problem for the director, Irvin Kershner. Once again, a seemingly minor facial problem had threatened to cause problems and potentially a large financial liability for the insurance company.

It was May 1983, and the male lead cast to play opposite Bo Derek in *Bolero* had yet to arrive in London to start principal photography. He had been in touch to say that he had developed a cold sore on his lip, and asked if I could send some medication. Plans initially were put in place for me to visit him at his home to assess the situation. His cast insurance medical had been done abroad, and he had not declared a tendency to develop cold sores.

I was asked for my opinion on how likely he was to transfer the infection to Bo Derek during a kissing scene that was to be shot right at the start of filming. Events moved fast, with John Derek, director of the film and Bo's husband, contacting their Hollywood doctor. The doctor recommended a minimum of 14 days from the infection clearing before a kissing scene should take place. This would cause a lengthy delay, which was a nightmare. I found it difficult to refute this with current medical thinking that herpes on the lip was no longer infectious once the vesicle had dried. I had to take into consideration that, if I forced the issue and Bo then developed a cold sore, the Medical Defence Union could face considerable damages.

The decision was made to immediately recast the actor, and a replacement was cast in time to start filming on the first day of photography. My visit was cancelled, and as the actor had not declared a tendency to develop cold sores during his pre-production medical, he received no compensation as a result.

Bolero was nominated for nine Golden Raspberry Awards and won six, including Worst Picture, Worst Actress, Worst Director and Worst Screenplay. Sometime later, it was nominated for a Stinkers Bad Movie Award for Worst Picture Ever!

Having previously been involved with the moulds for *Superman II*, in May 1983, I was asked to supervise the making of moulds for *Supergirl* and, specifically, to help in making the moulds for Helen Slater, who played the lead role. This meant there would be no issues with the flying sequences and no slipped discs.

I was called to see Helen, who had a scene in which she climbed up a fibreglass 'rock'. She had grazed her right cheek

during the action and developed a painful rash and rough skin. She had been seen by a central London GP, who believed there might still be some fibreglass in the cheek, and had arranged for Helen to see a plastic surgeon to operate and remove it.

After examining the area, I was convinced that this was a simple traumatic and allergic reaction aggravated by the excessive make-up being applied to her face every day. I cancelled the plastic surgeon, gave her some appropriate cream, and talked to the make-up department about my concerns regarding Helen's reaction to the make-up.

I asked Dr Richard Staughton, a senior dermatologist, to see Helen. Having made a diagnosis of occlusive folliculitis, he agreed that modifying the make-up should help the area to settle. Like all good dermatologists, he prescribed further topical potions, as well as aqueous cream to clean the area.

When I reviewed Helen's face three weeks later, I was delighted to see that she looked herself again.

I was lucky to have intervened before surgery was attempted, and fortunate that Helen's own doctor did not interfere with my taking over the management of his patient. This could be tricky at times, particularly when an actor insisted on following their own doctor's advice or prognosis. "Stay off work for two weeks" without a review of the situation during that time could make life very difficult for film-makers. So, in situations such as these, I tended to give my opinion regarding the real recovery time before filming could resume, but then regularly monitor the actor's progress. In film production, time and money go hand in hand and, fortunately, my prognosis of the length of time before an actor can return to work has generally allowed production to be accurately scheduled. Scheduling requires the production to check on the availability of

actors and of locations, so correctly anticipating when filming can restart is critical.

In June 1983, I was asked by insurers to help with Harrison Ford, who was playing the title role in *Indiana Jones and The Temple of Doom*. He had just returned from riding elephants on location in Sri Lanka, and had severe pain in his leg due to sciatica. I accompanied him to see a neurosurgeon, who confirmed a slipped disc, and recommended bed rest as the first line of treatment. However, clinical management of the problem might have required invasive intervention, given the physicality of the roles that Harrison played. Harrison asked for a steroid injection into his lower back to see if he could keep going. He managed to hold out for a week, but the pain became more extreme and, in late June, he returned to the United States for surgery on the slipped disc. I noticed that the production company had gone public about Harrison's back problem, announcing that he would be out of the film for four to five weeks as a result of an injury sustained while working on the film.

In mid-July, I went to Pinewood Studios to meet the director of the film, Steven Spielberg, who wanted to go over the action that was scheduled for Harrison upon his return from the US. The scenes were graphically illustrated in a large sketch book of drawings, called a story board, that itemised the essential details of all the action in the film. Steven talked me through all of this, and then we returned to the start and he asked for my views on the advisability of what was expected of Harrison in each scene. I raised some serious concerns, and he said he would look at doing those scenes some other way. I was less concerned about other scenes, raising only a partial red flag. I agreed to join him on

those days, realising what an enormous privilege it would be to watch the master film-maker at work.

Filming carried on while Harrison was still in the US, with some of the heavy action undertaken by his stunt double, Vic Armstrong, who was one inch shorter than Harrison, but in all other respects a perfect match. He also happened to be one of the most respected and able stunt men in the business. Much of the work on the sequences in the rail truck in the tunnel were done by Vic, and a few close-ups of Harrison were added in afterwards.

Once Harrison was back from the US, I travelled to Elstree to supervise those sequences about which I had raised some concern. The fight scene in Club Obi Wan was to be undertaken by Vic. However, there was one scene that Steven wanted Harrison to perform, providing I was happy for him to do it. This involved the baddies firing darts at him from ten or so yards away, and Harrison ducking to avoid them. As he wasn't required to fully bend over, I didn't think he would come to any harm. Harrison was keen to do this. In fact, if he had had his own way, he would have done anything he was asked to do and, at times, had to be held back. The four darts were to be released one after the other by a member of the crew pulling back an elastic bow and letting their missile travel down an almost invisible wire to embed in a target just behind the bending Harrison. The wires were so 'invisible' that, occasionally, members of the crew walked into them while setting up or adjusting something else on set. It was decided that tissue paper would be placed over each wire to prevent this from happening. Eventually the tissue paper was removed, Steven called "action", and the darts were released one by one. Harrison did his piece, ducking out of the way of the darts. Unfortunately, only three of the darts were released, which

had the potential to be a real issue in a scene which had taken so long to set up. Steven asked the crew man in charge of the fourth dart why he had not released it. The man replied that he had not heard the signal. As I looked on, my mind wandered to how this situation would play out on a Stanley Kubrick set. Consternation, cross words, followed by hours of resetting and endless takes. No such thing happened on Steven Spielberg's set. The director walked forward and asked Harrison to be where he would have been under the fourth dart. Steven then lifted both hands to the side of his face to frame an imaginary shot before turning to check with the cameraman that the take with the three arrows was safely in the can. He then announced that he would do a close-up on Harrison under the fourth dart. To say that I was impressed would be an understatement. He had thought on his feet, rather than sticking to the overnight schedule of takes and the story board. In so doing, he had created something better out of this potential time-sapping issue.

I also remember being involved in the pick-up scenes on the interiors of the mines and Quarry Cavern, and the fall from a window to the exterior of Club Obi Wan.

The budget for the film was around $28 million, and the worldwide gross takings were $333 million. The loss for the insurers was around $1 million, thanks to Steven's adaptability and Harrison's excellent stunt double who kept the production going while the principal actor was out of action for around five weeks.

In early October, I saw Terry Gilliam, Jonathan Pryce and Robert De Niro for their cast insurance medicals for the film *Brazil*. In contrast to *Indiana Jones*, *Brazil* took less than $10 million at the box office, although it subsequently became a cult movie.

On 31 October, there was a terrible accident at the start of principal photography on *The Shooting Party*, a film based on the book by Isabel Colegate. The accident happened on the very first take, which involved a horse-drawn open carriage in a field at Shardeloes Park, near Amersham. The carriage contained the actors Paul Scofield, Robert Hardy, Edward Fox and Rupert Frazer and was driven by an experienced film horse-master, George Mossman, who was standing up holding the reins. The wooden platform on which he was standing was riddled with woodworm, and during the action it broke in two. He fell between the wheels of the carriage, still clutching the reins, and was kicked on the head by a horse's hoof and concussed. The horses were startled and began to gallop down the field towards an adjacent busy road. Just before they reached the road, the carriage overturned, resulting in serious injuries to the actors.

Rupert Frazer escaped with bruises and scrapes, and Robert Hardy was taken to Wycombe General Hospital, where X-rays revealed no fractures.

Edward Fox sustained a fracture in his ribcage, and his shoulder and elbow were injured, but not fractured. With physiotherapy, he made good progress, and had regained sufficient mobility in his shoulder and elbow that he could take part in filming when production resumed on 12 November.

Paul Scofield did not escape so lightly. He sustained a fracture to his leg, and his continuing participation in the film was in question. I was asked to see him in hospital to discuss this with him. The production was so keen for him to take part that they came up with a scheme whereby he could play his role as Sir Randolph Nettleby from a Victorian wheeled day bed. I discussed this option

with Paul. He listened to this idea, thought for a moment or two, then made it clear that he had learned the part and visualised each scene with his walking and movements clear in his mind. He could not now play the part in a different way, and politely refused the offer. I relayed this back to the production company, who were now faced with the dilemma of finding an appropriate replacement actor to play Sir Randolph Nettleby. They hoped to persuade James Mason to take on the role, but he was already filming *Dr Fischer of Geneva*, which was currently being shot on location in Switzerland. This was tricky, as the schedules of both films would have to dovetail precisely to avoid hold-ups at either end. Clearly *Dr Fischer of Geneva* would have first call on his time, and flights would have to be organised for travel between the two production sites. James was cast in the role and filming restarted in early December. On 20 December, James was taken ill and I was asked to see him at the Dorchester Hotel. He had arrived in London 48 hours earlier, having completed five nights in a row of filming. Since arriving in the UK, he had been involved in cold, rainy exterior filming. I was not surprised that he was unwell, since this was a punishing schedule for anyone, let alone a 74-year-old man.

Sadly, he died a year later, and I attended his memorial service at the actors' church, St Paul's in Covent Garden. Sir John Gielgud gave the address and Spike Milligan read *Isabel, Isabel* by Ogden Nash. The congregation also listened to recordings of James Mason himself, reading Robert Browning's *Home Thoughts from Abroad* and *Prospice*, as well as 1 Corinthians 13.

In mid-November, I saw Cyril Cusack, who was also in *Dr Fischer of Geneva*. His daughters, Sinead, Sorcha and Niamh, are all also distinguished actors. Cyril mainly worked in the

theatre, particularly in Ireland, where he had his own production company and managed the Gaiety Theatre in Dublin. I learned from a fellow thespian that he enjoyed improvising. On one occasion, this actor was asked by a fellow actor in a play why the hysterical line that he delivered every night consistently fell flat.

No laughs at all.

"Don't you know why?"

The baffled actor shook his head.

"You are front of stage, and 60 seconds before you are to deliver your line, Cyril, who is leaning against a fireplace at the back of the stage, takes out the fob watch from his waistcoat pocket, looks at it, checks stage left, puts it back, and 30 seconds later repeats the process. Just before your line, he takes the fob watch out again and he looks to move to stage left. Now he has the audience's full attention, and he has managed to screw up your line. Job done as far as he's concerned!"

In early February 1984, director Tobe Hooper came to see me prior to starting work on the sci-fi epic *Space Vampires*. I had met Tobe four years earlier and got to know him well, and had even visited him at his home in Los Angeles. He had made his name as the writer, producer and director of *The Texas Chainsaw Massacre*, a film that cost $140,000 to make and grossed over $150 million, helped by being marketed as based on true events, which was a ploy to attract an inquisitive audience.

When Tobe first came to see me in 1980, he noticed the book, *How to Manage your Mother*, by psychiatrist Margaret Reinhold, in my bookcase. I had taken many patients to see Margaret, sitting in on consultations, and I had learned enormously from her gentle approach and skill. Tobe remarked,

"I wish that I had known about this book years ago." He was not the first to notice the book, as many actors who came to my office had said more or less the same thing. I proceeded to try to get Tobe to open up,

"Tell me about it, if you want to."

"Well, when I was a child, my mother's method of punishment was guilt. I still have so much guilt as a result. Trying to get away from home, I married at 20, had a son, then my marriage quickly fell apart, as my mother managed to destroy all of my relationships.

"She also insinuated that I was responsible for the breakup of her marriage to my dad. Mum looked after my son, Tony, for a while after the breakup of my marriage and, in her mind, Tony was the son she wanted and not me, and she made this absolutely clear to me. Later, when my life was more stable, I tried to have Tony live with me, and then my mother refused to release Tony and cut off all communication with me. It's not been easy and, at times, it's so bad that I find work difficult."

"I completely understand," I replied. "You have really suffered, so borrow the book and when you have finished reading it, we can discuss some of the coping skills that she recommends. Also, please return the book, you are certainly not the only one who has these issues and I would like to be able to lend it to others in your situation in the future."

Mathilda May, an 18-year-old French actress, was cast as the vampire in *Space Vampires*. Other members of the cast included Frank Finlay, Patrick Stewart and Peter Firth. In the end, the film was released under the title *Lifeforce*. Although it was not a commercial success, it still has a cult following.

As the Alien Vampire, Mathilda was naked in most of the film, because she seduces humans to kiss her, after which she drains their lifeforce.

I recalled a conversation that had taken place with George Lucas when he directed the first *Star Wars* film. The costume department brought Carrie Fisher to see him in the dress she would wear as Princess Leia. This was a beautiful and long white dress similar in design to the one we all know so well from the film, except in one respect. The top of the dress finished just above her breasts, so that they could just be seen, making it rather erotic. George paused for a second, then turned to the costume-maker.

"Take the dress right up to her neck please. There is no sex in space."

The film was, in his view, about excitement, storytelling and fantasy for all the family and should not have the confusing element of an erotic heroine. So, it didn't surprise me when the Cannon Films production of *Lifeforce* bombed at the box office. But that didn't stop Menaham Golan and his cousin, Yoram Globus, the Cannon team, from making several more stinkers. Their company assets showed the production cost of a movie on their balance sheet, rather than the box office takings after its release. This hugely overvalued the production company and, as always happens after a period of dodgy accounting, they stumbled, and Cannon Films went bust.

Incidentally, four months into filming, I was asked onto the set. I was talking to an assistant director and asked how Mathilda May was getting on in her role. He told me she had started 'seeing' one of the crew members and the rest of the crew now knew her as 'Mathilda Will'.

*

On 22 March, the unmistakable figure of Sir Harry Secombe walked into the consulting room, and immediately put a smile on my face. He was appearing in *Highway*, a TV show with a mix of hymns and chat from various locations across Britain. He had heard that I had a penchant for limericks, and every time he came to see me, he arrived with another volume, often having scoured a second-hand bookshop to find it. My secretary/nurse, Hilary, always remarked that when Sir Harry was in the consulting room, she could hear us enjoying ourselves and laughing. He also enjoyed golf, and hosted a charity golf day at Effingham Golf Club, and kindly invited me to the day as his guest. This was a light-hearted affair, which was very well attended by the public, as Harry had no problem accumulating a large gathering of celebrities, with one in every team of four players.

Billy Connolly was in the film *Water*, which was mainly being filmed in St Lucia, with the studio work being filmed at Shepperton Studios. Billy had been involved in a motor accident, and he had some facial bruising and a black eye. In early July, I visited him at a house in Fulham, where he was living with Pamela Stephenson, to assess the extent of his injuries. Fortunately, they were only superficial, but they would clearly complicate the filming schedule. While we were talking, I mentioned that I was going to a fancy-dress party that evening hosted by some Persian friends. I admitted that I had nothing appropriate to wear to the party, whereupon Billy shouted, "Pamela, Doctor's going to a fancy-dress party tonight and he has nothing to wear."

Pamela appeared and, in no time, they had me stripped to my underpants, with all their clothes cupboards flung open. I was soon dressed up in an assortment of clothing belonging to The Big

Yin and Pamela. The array of colour got huge applause from the upmarket Persian crowd when I appeared at the party. I returned the clothes the next day and mentioned, on the off-chance, that I had a spare ticket for Centre Court at Wimbledon.

Without skipping a beat, Billy said, "Yes, Pamela would love to come with you."

I returned later to pick her up, and she appeared wearing a hat with a large parrot on top. Naturally, this attracted attention as we walked about the grounds, and it did not take long for the television cameras to pick her out and return to catch her expressions from time to time. By sheer happenstance, the person sitting in front of us was wearing a T-shirt with a parrot on the back. Pamela could not resist bending forward so that the two parrots could approximate and engage in a chat: cue the television cameras!

A week later, I was asked to see Tim Curry, who had been cast as the Lord of the Darkness in *Legend*, which was being directed by Ridley Scott and filmed on the 007 stage at Pinewood Studios. Ridley had seen Tim in *The Rocky Horror Picture Show* and thought he would be perfect for the part.

It took five and a half hours and three make-up artists to apply Tim's make-up each day, as his whole body was encased in it. He had to wear a large bull-type head, supported by a harness underneath. The rest of his make-up/costume was glued to his body and a considerable amount of time was required at the end of each day's filming to remove this. The day before I was called to see him, the bull head had been adjusted rather quickly, using acetone to release the glue, and then glued back on again.

As a result, he had a large blister on his forehead, as well as blisters on his back. I gave him appropriate creams for this, and

arranged a joint consultation with the eminent dermatologist, Dr Peter Copeman. Peter and I were both of the view that the trauma to Tim's back was due to the glue not breaking down sufficiently, causing redness and irritation due to the suction effect as the rubber was pulled off. We also felt that acetone left in contact with the skin on the head for several hours, after the adjustment had been made, was the cause of the large blistering on his forehead. Tim recovered over the next few days, and precautions were taken to ensure that this did not happen to him or to other actors in the film again. At the time, this was one of the most make-up-intensive films ever made, and it may well be that no film since has required so many make-up artists to prepare the actors each day.

One of the most notable events during the filming of *Legend* occurred on 27 June, when several left-over canisters of petrol used during filming caused the 007 stage to burn to the ground. Cubby Broccoli, the James Bond franchise producer and, therefore, owner of the 007 stage, was dining at a West End restaurant when a message was relayed to him that he had lost his stage. He was about to start shooting the next Bond film. He pondered the situation for a second and then asked for the maître d' to bring him a telephone. He then proceeded to book every available large film set, so that he could start filming on the next Bond film on schedule. The stage was rebuilt and ready for filming about eight months later.

At the end of November, Freddie Mercury was on tour and he was having problems with his voice, which threatened to interrupt several performances. The ENT (ear, nose, throat) specialist who had first seen him had written:

"Generally, he was well with no evidence of any pyrexia or infection. His larynx showed evidence of irritation with congestion of the vocal cords. This was diagnosed as an irritant laryngitis due to climatic factors associated with low humidity and high altitude."

In response to this, the underwriters had responded to the loss adjustors with:

"As there was no evidence of fever or infection and the condition was caused by climatic conditions, I fail to see what 'illness' Mercury was suffering from."

Insurers were wriggling their way out of paying on this claim, and voice problems were often a bone of contention.

Looking into the circumstances around this claim, I wrote:

"I believe that, from the evidence that we have, Mr Mercury suffered from an irritant to his throat, which was indeed accidental, and was due principally to the low humidity. This would, therefore, fit into the section relating to a loss 'Resulting from the inability of an injured person to sing, arising out of an accidental injury'. This injury then caused the 'illness' which was the congestion of the cords and the irritant laryngitis. Quite clearly the question of whether this falls into the section of an accidental injury or an illness is to some extent academic, since I believe that the accidental injury of the dry atmosphere, as clearly stated by the ENT specialist, then caused the illness. I have checked with the British Medical Dictionary on the definition of somebody who is 'ill', which is:

1. Not healthy.
2. Indisposed.
3. Suffering from an illness or disease.

It was clear that Mr Mercury was both not healthy and indisposed, so I think, therefore, that the condition from which he was suffering could fall into all of these categories. I feel that if the policy had been written expressly to exclude voice strain, they could use that to refuse to cover the loss, on the grounds that singing strained the vocal cords and the low humidity added to the possibility of laryngitis. In the event of an infection of the throat, it is also sometimes the combination of the inflammation due to the infectious process, and the strain on the cords due to singing that causes the loss of voice. In spite of the difference in causative agent, the end result is the same."

The insurers settled the claim and my opinion may have helped to prevent litigation, from which the only winners would have been the legal profession. (Apologies to my lawyer friends!)

The French singer Johnny Hallyday was performing at Coleman Zenith, a Paris venue, in mid-January 1985, when he felt faint and had to leave the stage. He was admitted to The American Hospital in Paris, where he underwent a series of tests. I visited him in hospital on behalf of Lloyds of London, and had a joint consultation with his cardiologist. Nothing substantial was discovered, but I was interested in the background to this episode.

Johnny told me that he had been working on a Jean-Luc Godard film, *The Detective*, since July 1984, and filming had taken three weeks longer than scheduled to complete. As a result, he had been forced to begin rehearsals for his show at the same time, during the evenings. He had done this for the last three weeks of filming, and then went straight from filming to beginning the show. Before the film, he had been recording in Nashville, and his last real holiday had been in February 1984.

Unfortunately, this clash of commitments occurs all too often for high-profile 'stars', leading to fatigue and other problems. Agents are only too keen for their clients to take on a job, and sometimes leave little time to take a break, or indeed wiggle room, when projects take longer than anticipated to complete.

8

Trouble in Moscow

In late February 1985, I flew to Moscow to see Maximilian Schell who was playing the title role in *Peter the Great*. Maximilian was an Austrian actor who came to prominence in 1961 in *Judgement at Nuremberg*, and won an Academy Award for Best Actor for his portrayal of a defence lawyer, Hans Rolfe.

He had been unwell for a while, and had been seen by the resident doctor in charge of the US Embassy community in Moscow, and he had received a second opinion from another doctor who had flown in from Germany.

Over the ten days preceding my visit, I had been in touch with Maximilian by telephone, and had talked to the producer and to Maximilian's agent. I felt he should consider leaving Russia for Germany or London to convalesce, as either would offer him a

more favourable environment than staying stuck in his hotel room in Moscow. I also felt that he would benefit from an improved diet with fresh meat and vegetables, which were, at that time, difficult to obtain in Russia. He could have supervision from Western doctors and nurses, and he would not be in an overheated hotel room with a very dry atmosphere. I also suspected that he was seeing other actors late into the night, during which he was smoking heavily and perhaps drinking. The insurers' doctor in Los Angeles felt there was no sound reason why he should move, although he did agree with me on the advisability of it. In spite of attempts by myself, the producers and his agent, Maximilian would not be persuaded to leave Moscow. It was for this reason that I travelled to Moscow to see him. His refusal to move became clear, as did the fact that this was related to his personal circumstances. His mental state, which included paranoia, became evident during my consultation, and was the reason why he refused to leave Russia.

I was driven from the airport to the hotel. I dropped my bag in my room and was then taken to see Maximilian. On each floor, adjacent to the stairs and lift, there was a desk, behind which sat a frightening lady, known by the locals as a *babushka*.

She was there to monitor the comings and goings on each floor, and her presence was indicative of the persisting surveillance at the tail end of Soviet communist control.

I knocked on Maximilian's door, and a deep voice welcomed me in. I found him sitting in a chair wearing a large brown coat that could well have come from the film's costume department. Before I could speak, he put a finger to his lips, indicating that I keep silent and, at the same time, pointed up at an area on the ceiling with his other hand. Was this paranoia, or was there really a listening device in the room to keep tabs on his communications?

He slowly got out of his chair and walked over to a breakfast bar where there was a kettle. He filled the kettle and plugged it in. Once it was noisily coming to the boil, he beckoned for me to move closer to him.

"They are listening to everything we say," he whispered. "So, we have to be careful."

"I completely understand," I replied, not certain that a discussion about his health would be of much interest to the hidden listeners.

He made us both a cup of tea, and we discussed his influenza that had turned into bronchitis. I said that I would try to arrange sinus and chest X-rays as soon as possible. We chatted about the working conditions in the studio, and I reassured him by saying that I would take a look at the studio for myself.

He was a great admirer of the English stage, and Shakespeare in particular, and said that he would like to play the famous *Hamlet* soliloquy "To be or not to be" by having Hamlet address this to his dog. I don't believe that this is something that has ever been attempted, and it could bring an interesting dimension to the play.

The outside temperature went down to minus 15°C at night, but the ambient temperature during the day was comparatively warm and probably around zero. The temperature and the conditions in the studio were satisfactory, and not very different from Pinewood or Shepperton studios. While at the studio, I went through Maximilian's remaining pieces of action with the director, Marvin Chomsky. Maximilian had suggested that it might be appropriate for him to next film a tent sequence in which Peter the Great is recovering from an illness. Marvin agreed to this.

I learned that there was also some concern about Vanessa Redgrave, who was playing Tsarevna Sophia. She had been seen standing on the studio steps handing out leaflets voicing her concerns that the great Trotsky revolution had been lost and needed to be revived. The production company was told in no uncertain terms that this activity had to cease immediately.

I arranged X-rays for Maximilian that confirmed a sinus congestion, and I advised him to continue with his antibiotic course and with steam inhalations. He was reassured that there was no pneumonia, and this helped him to feel better. He was scheduled to start filming after a further few days' convalescence.

That evening, I had dinner with the producers and Marvin Chomsky. We were joined by Lilli Palmer, a star from Hollywood's heyday, who still looked wonderful, helped, I suspect, by a little tuck here and there. Sadly, she died soon after, and her role as Natalya in *Peter the Great* was her final performance.

The next morning, before flying back to London, I paid a final visit to Maximilian in his hotel room. We went through the charade of boiling the kettle before our whispered consultation. I had learned over dinner that Maximilian had started a relationship with Natalya Andreychenko, a beautiful Russian actress who had a high profile in Russia following recent successes playing the title roles in *Mary Poppins, Goodbye* and *Wartime Romance*. Clearly the relationship would be a matter of great concern to the authorities in a country where it was still impossible for citizens to leave, and where, with her high profile, it would cause great embarrassment if she were to suddenly disappear to the West. The reason for his secrecy, paranoia and nervousness about being overheard suddenly became clear. Maximilian was keen for me to meet her, and he managed to get her to his room, where he introduced us.

Afterwards, I left for the airport and flew back to England.

Maximilian continued to complain of feeling unwell, and suddenly left Moscow, flew to Berlin and checked into a clinic there. The insurers asked that the Berlin doctors keep me up to date. Maximilian gave them express instructions not to give me any medical feedback, and shortly afterwards told the production that he would only complete filming in Germany. This would require Natalya to fly to Germany to be in some of those scenes. The picture was becoming clearer!

In no way were the authorities going to let Natalya fly to Germany, so the production would have to be completed in Moscow. The only way out was to make a facial mask replica of Maximilian and to complete the filming with another actor wearing that mask. They then had to do a voiceover of Maximilian's dialogue for the whole show.

Later, as the political situation in Russia eased, Natalya joined Maximilian abroad, where they married and had a daughter, Anastasia.

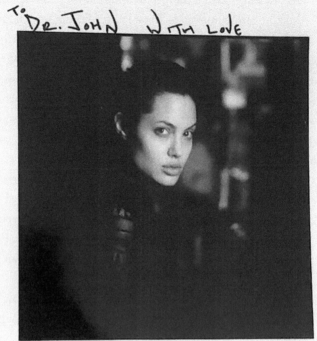

Angelina Jolie."You saved me!"

Peter Ustinov, the ultimate storyteller.

Brad Pitt. Sadly not with Angelina now.

The Cardboard Walter PPK.

John Gayner and Pierce Brosnan and the Cardboard Walter PPK.

John Cleese showing his feminine side.

Johnny Depp. Filming on hold (at present).

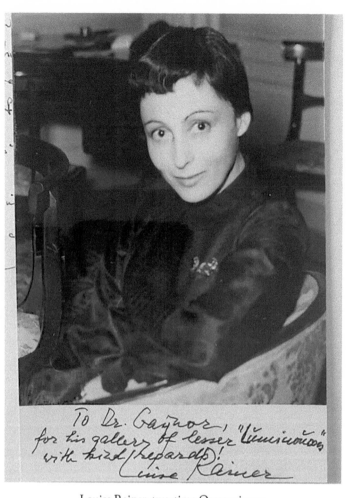

Louise Rainer, two-time Oscar winner.

Ronnie Corbett, a lengthy storyteller.

Emma Thompson and family. " What's the word?"

Lady Margaret Thatcher. "The Lady's not for turning."
Neither is the doctor.

Rita Ora. "Rita, do you know the word?"

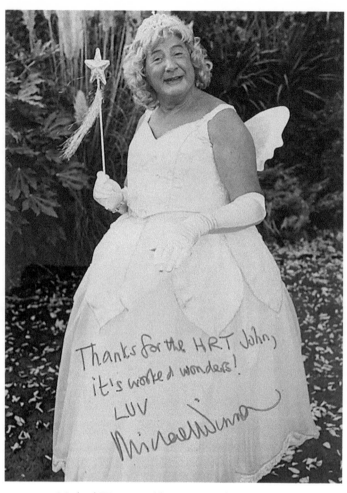

Michael Winner and his curiously feminine side.

Paul Scofield. Thomas More in *A Man For All Seasons*.

Pat Cash and Wimbledon Men's Singles Cup.

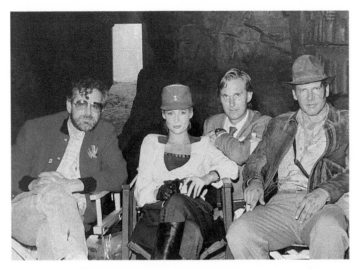

Steven Spielberg, Kate Capshaw, John Gayner, Harrison Ford.

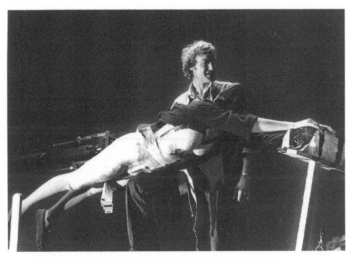

The front mould for the flying sequences in Superman.

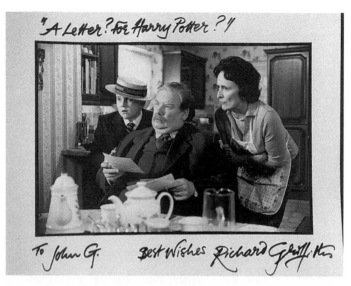

"A Letter? For Harry Potter?!"

To John G. Best Wishes Richard Griffiths

"What part are you up for, Dr Gayner?"

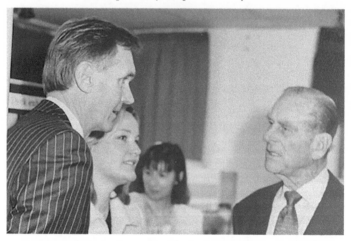

Prince Philip, listening patiently to John Gayner storytelling.

9

Theatre, TV and some anecdotes

In mid-February 1985, I carried out a cast examination on Irish actor, Ray McAnally, for *Surrender* and again for *The Mission*. Ray's acting work had mainly been on the stage in Ireland, but once *The Mission* was released, his career took off and he was offered more film and TV parts. In 1988, he played George Bernard Shaw in *The Best of Friends* at The Apollo Theatre, with Sir John Gielgud as Sydney Cockerell, curator of the Fitzwilliam Museum, and Rosemary Harris as Dame Laurentia McLachlan, a Benedictine nun and Abbess of Stanbrook. I went to see the play and was interested to see that the actors remained in the same position on the stage throughout the play, with Ray MacAnally on the right, Rosemary Harris to the rear and John Gielgud on the left. They read letters to each other, and used the telephone.

The Abbess was in a closed nunnery, but she was due to come out on one occasion, and this was the subject of much discussion. Both men had clearly fallen in love with her, and the outing was an event of great significance for them all.

At the end of the play, I decided not to go around to see Sir John, who was one of my patients, as I felt sure that there would be a crowd of admirers besieging him for autographs.

When he next came to the practice, I mentioned how much I had enjoyed the play, and he commented, "I didn't 'dry' did I?" he asked, meaning, had he forgotten his lines.

"No, you had no problems, and the play was wonderful," I replied.

"You see, I always was prone to drying. Binkie Beaumont used to say, 'Never mind. Push her out on a throne with a crown on her head, she'll be alright on the night.'"

Binkie Beaumont was the *éminence grise* of the West End theatre and a theatre manager and producer in the 1940s and 1950s. He controlled many of the productions of that time, and being liked by Binkie was essential to being cast in his plays.

Somewhat later, when *The Best of Friends* had ended, I saw Ray McAnally, and told him what Sir John had said. Ray recounted that, one night, there were three elderly people seated in the front row stalls, in front of where he was stationed as Bernard Shaw. For much of the play, they dozed in the warm, comfortable seats. The evening had gone well, and as the three actors took their curtain call, Ray turned to John and remarked, "That seemed to go well tonight," to which Sir John replied, "At least I kept my lot awake."

At the end of show party, Sir John gave Ray a gift of a belt. Ray thought this was interesting but remained unsure of its significance.

Ray died shortly afterwards, far too soon, and just as he was gaining recognition as the fine actor that he was.

In March 1985, Michael Winner was about to direct *Death Wish III*. I went to his home in Kensington to conduct a medical. His house was large and, walking through the hall, I noticed a large whip propped up against a wall. I made a note to try to establish whether this was purely for decoration or a prop to ensure that anyone entering his domain knew who was boss.

For insurance purposes, Michael had been designated an 'essential element'. This meant that the insurers could not force the production company to continue production with another director should Michael become incapable of completing the film due to illness or injury. This made the risk to the underwriters much higher, and they requested a much more extensive pre-production medical than the usual cast medical. It involved blood tests, an electrocardiogram, and a chest X-ray, in addition to a history, examination, and urinalysis. In instances such as this, if a director or actor has had a recent blood screening, then a copy of the results avoids the necessity of another test. In due course, the national policy on routine X-rays ruled them out as a necessary examination, except for smokers. Michael had a set of recent blood tests, and he gave me a copy of the results. I conducted the rest of the medical and would next see him on the set of the film.

Two months later, I was asked to go to a building site behind a row of houses in Lambeth, where *Death Wish III* was being filmed. I entered through a space where there would have been a door, into a scene of knocked-down walls, piles of bricks and a fire on one side of the open area.

I had come to see Charles Bronson, the star of the *Death Wish* franchise, who had an upper respiratory tract infection. The second assistant director took me to an upstairs room where I could examine Charles, and sort him out with antibiotics. He had been a smoker, but had stopped eight years earlier, and was in good general health. He felt able to continue working, and I told him there was no medical reason for him to stop, providing there was no deterioration to his condition.

The assistant director was waiting outside the room and I gave him the prescription. As we walked down the stairs, he said that Mr Winner wanted to see me. I was taken to Michael, who was on the set talking to the cameraman. He turned to question me.

"What is wrong with my actor?" he said rather aggressively.

"He has an upper respiratory infection," I replied.

"I see, and what are you going to do about it?"

"I have prescribed some antibiotics," I told him, "And I've instructed him to stay warm and to keep away from smoke."

"So, if he does not get better, we will know who to blame."

I turned to walk away and, as I did, I responded, "Yes, it will be the man smoking a large cigar in close proximity to his actor."

When I had walked into the open space of the location, I had noticed that the director was hiding a large Havana cigar behind his back.

"Gayner, come back here." A smile broke across his face.

"It's John, isn't it?"

"Yes, Mr Winner."

"Please, it's Michael from now on. And do you think you would be able to monitor Charles's progress on a daily basis for me?"

"Thank you, Michael, I would be delighted to do that."

Over the next two days, Charles Bronson's health improved, and my relationship with Michael Winner remained transformed by my having stood up to his bullying.

That same month, a stuntman/actor working on *Death Wish III* was injured.

The action required him to jump and fall over backwards with outstretched arms while being shot at. There was nothing to break his fall and, although he had a pad on his back, there was nothing to protect his shoulders and neck. This resulted in spasm in his neck muscles and limitation of movement of his head.

In another scene, Charles Bronson fired a gun with a blank cartridge at the stuntman as he came close. This resulted in a spray of hot particles into the stuntman's face, neck and upper chest. I noted small circular abrasions on his arms, neck, cheeks and chin, and he also had some shrapnel on his tongue.

The proximity of the gun being fired had also caused a severe ringing in his ears (tinnitus), and temporary deafness.

Fortunately, none of these injuries were long-lasting and he made a good recovery, but these were further accidents to add to the list of film-set risks. And there were to be others, some that were more serious.

In June, David Bowie was at Elstree studios filming *Labyrinth*. He had been filming for two weeks and had developed a reaction on his face. I went through the make-up that was being used, and the procedure to remove it at the end of each day's filming. I concluded that there was a preservative in the moisturiser and suggested changing to a simple 1% hydrocortisone cream until the skin returned to normal. I noticed that his right eye was

dilated compared to his left eye and I inquired about this. He told me that he had suffered a bad accident aged 13 which had caused this, but that, fortunately, it had not been picked up by fans watching his music videos.

In November of that year, Lee Ermey was hired as military adviser on Stanley Kubrick's film *Full Metal Jacket*. His background as a drill instructor at the Marine Corps Recruit Depot, San Diego, and active service in Vietnam, made him eminently suitable for this position.

Initially, he was a technical adviser, but after he had put together some instructional tapes in which he went on a tirade against some extras, Stanley Kubrick decided to cast him as a gunnery sergeant in the film.

Because he was now cast in the film, I had to carry out a medical. I specifically asked whether he had ever had problems with laryngitis and discussed his ability to loudly order troops around. He assured me that during his time in the army, when he had to shout at trainee soldiers for extended periods, he had never lost his voice.

However, a couple of days before Christmas, he developed a sore throat, which troubled him for two days. On 28 December, he had to do a sequence which involved loud shouting and giving instructions to some 'soldiers'. Stanley was unhappy with his voice, and sent him to see his GP, Dr Cox, who diagnosed laryngitis, prescribed antibiotics, and told him to stop smoking 20 cigarettes a day.

I saw him two days later, by which time he was fine, with a little redness in the throat but no fever or mucus. He was set to work on 2 January 1986, but his vocal intensity still did not

match its level prior to his bout of laryngitis.

I arranged for him to see Mr Norman Punt, an eminent ENT consultant who specialised in the voice problems of singers and actors. He prescribed some medication and we had a joint consultation on 12 January. We found his vocal cords to be normal and his voice strong, so we pronounced him fit to work on 13 January. This was unsuccessful, possibly because of a reaction to one of the medications, and he became forgetful and couldn't remember his lines. There may have been other factors too. As a soldier who was used to being given orders and carrying them out perfectly, the pressure of taking instructions from Stanley Kubrick, and then being told he was not up to scratch, was extremely difficult to take.

On 24 January, it was again decided that he was fit to work, and Dr Cox and I told Stanley that Lee was fit to work but that he should be gradually re-introduced to filming by working half days to start with. The director stated that Lee Ermey was no use to him unless he was 100% fit. At this stage, I felt that the prognosis had to be extremely guarded, to avoid any change in the production company's attitude.

The next day, Dr Cox said that he no longer wanted to conduct joint consultations with the insurer's doctor, although he was not forthcoming as to exactly who had instructed him to say that joint consultations were off. He stated categorically that he was not prepared to discuss the matter further. However, he pronounced that Lee Ermey would be 100% fit to perform in two days.

I suspected that Stanley was pulling the strings and trying to control all those involved in this complicated case. The fact that he was causing stress to his actor, Lee Ermey, and making him do

multiple takes that involved loud shouting in an open space at the Becton gas works in the East End of London, was not helping. He wanted me off the case because I was pointing this out to the loss adjustors, and there was going to be difficulty over the production's claim for slowing down the film.

Subsequently, it all worked out for Lee Ermey, as he was nominated for a Best Supporting Actor Golden Globe.

In the midst of this, Sir John Gielgud had come to see me before flying to Hollywood in the New Year to play Aaron Jastrow, a Jewish doctor, in a TV series, *War and Remembrance*. This was a big Hollywood TV show also starring Robert Mitchum, Jane Seymour, Chaim Topol, Ian McShane, and Sharon Stone.

Sometime after filming, Sir John described it to me.

"I've been in Hollywood filming *War and Remembrance*," he said.

"Yes, John, I remember doing the medical for that."

"There's this scene where I have to take off all my clothes and go into a room with bare brick walls [gas chamber] and lie down on top of a room full of naked men. Mind you, the Americans are very keen on team sports."

In 1986, I was asked to see a number of well-known performers for different shows, including Peter Cook, Madonna, Annie Lennox, Kevin Kline, Kirk Douglas and Joel Grey. Fortunately, there were few crises on the productions these stars were involved in. One of the medicals that I carried out that year was with Sir John Mills, who was brought to see me by his granddaughter, as his sight was poor. He was beautifully dressed in a suit and tie and perfectly polished black shoes. I remarked on this, and he told

me that, until the sixties, all actors would go to casting sessions dressed like that, with hat and gloves and, if there was a possibility of rain, a rolled umbrella. What a contrast to the clothes that had, by now, become considerably more casual. This applied to actresses as well, who often appeared in jeans and T-shirts, in contrast to the yummy mummies, dolled up to the nines, who dropped their little darlings off at the school around the corner from the practice.

In the summer of 1986, Michael Barrymore was performing at Great Yarmouth during the week and travelling to do his show at Scarborough at the weekends. He had been troubled with voice problems, and been seen by Mr Norman Punt, the ENT voice specialist, who sadly died shortly after his consultation with Michael. Michael's voice problems were aggravated by singing at the two venues and, at the same time, recording a TV show. Mr Punt recommended dropping the Scarborough shows to give his voice a chance to recover, but there were contractual problems with continuing to perform in one venue and not the other. Some dates were lost, the consequences of which had to be picked up by the insurers. Later, Michael, had become one of my regular patients, and I was sad when a well-publicised drowning accident at his home resulting in the subsequent loss of his performing career.

In early November, I was asked to see a 12-year-old, who was appearing in *Empire of the Sun*. The boy came to see me with his mother. I was impressed by his maturity but had no idea how his career would take off as an adult. His name was Christian Bale, and I would see him again into his early twenties, before he disappeared into the heights of stardom in Hollywood.

*

In February 1988, Bob Hoskins was filming *Who Framed Roger Rabbit* at Elstree Studios. The eponymous rabbit was animated and the film mixed live action with animation throughout. The opening scene is a classic, with an animated sequence that suddenly comes alive with actors moving around in the animation. Bob had asked me to go to the studio to discuss a medical problem. While I was there, he talked about the film. The production team had created a cut-out Roger Rabbit to be placed in the position where the animated Roger would appear once the animation effects had been created. The cut-out was removed and then Bob acted as though Roger Rabbit was in front of him.

Charlie Fleischer, an American stand-up comedian who had appeared in *A Nightmare on Elm Street*, had been cast as the voice of Roger Rabbit. Bob told me that there was consternation on set on the first day of filming when Charlie appeared and asked, "Where is my Roger Rabbit costume?"

"But Charlie," replied the director, Robert Zemeckis, "You do not appear in the film yourself. You are the voice of a cartoon character."

"I cannot play Roger Rabbit unless I am dressed up as Roger Rabbit."

"Okay," the director conceded. "We will get the costume department to make you a costume."

Bob then said that, once in the costume first thing in the morning, Charlie would lunch in the studio dining room wearing it and, on one occasion, when Charlie and Bob had agreed to have a pint in a local pub, Charlie showed up dressed as Roger Rabbit. Charlie also suggested that if he stood behind the camera dressed as Roger Rabbit to speak his part, his being in costume would help

Bob feel that Roger Rabbit was real. Nothing could be further from the truth, and Bob found the whole thing very entertaining. The film was a huge success and won three Academy Awards for various members of the production team.

In early May, I was asked to go to the set at a London studio to have a discussion with the producers of a high-budget film. They were concerned that one of their leading actors was drinking heavily at times, and this meant that several of their scenes would have to be reshot early in the morning on the next day. They were aware that the actor had an alcohol problem. In fact, this was an exclusion in their cast insurance cover for him. I agreed to see the actor and to see if there was any way to prevent him from becoming so intoxicated that filming was impossible. We had a discussion and I put a proposal to him. He was to give a cough when he felt he urgently needed a drink, and I would brief the unit nurse to come over to him with a bottle of 'cough linctus' and give him a tablespoon of medicine. The cough medicine bottle would, in fact, contain brandy, and this ruse would both restrict his intake and avoid him feeling embarrassed in front of the other actors and the crew. I made it clear that an assistant director would remain with him over the lunch break to ensure that he did not top up, and his room was to be free of bottles or a hipflask. He seemed relieved with this proposal, and filming was completed without any further delays, with multiple coughs on set each day.

In mid-July, I flew to Belgrade to see Caleb Deschanel, who had himself just flown there from the Seychelles, where he was directing a Robinson Crusoe variation, later released as *Crusoe*.

Much of the filming for *Crusoe* had been undertaken in the shallow water off the island of Praslin. A galleon was the focus of the water scenes, and many of the film crew were in the shallows around the ship, wearing diving fins if needed for deeper water and to help them move around more quickly. Mr Deschanel had been working as normal one day, when he had felt a stinging pain in and around his left foot. By the end of the day, the pain had become intense and, that evening, he was taken to see a nurse at a local hospital. She said the foot was infected, gave him an antibiotic and discharged him back to his hotel. Later that evening, the foot started to swell up and he became feverish and very unwell, so went back to see a doctor.

The doctor recognised that he had been stung by a stonefish and gave him an injection of cortisone and a powerful pain killer. He stayed in hospital on intravenous fluids. Two days later, he was on a charter flight to Belgrade, where studio filming was about to start.

On arrival, he was again feverish and in intense pain and was admitted to the Bezanijska Kosa Hospital. The decision was made to operate and incise the area of the stonefish sting, as this had probably developed into an abscess. At the operation, there was some pus, but the significant finding was a considerable amount of necrotic tissue that had to be surgically removed. Initially, the resulting wound was too large to suture.

Before flying to Belgrade to see Caleb, I looked up stonefish sting, since not many stonefish sting patients come into our central London practice.

Stonefish are found in India, the Philippines, Australia and the Seychelles. A sting from the needle-like spines in their dorsal fin can be deadly, causing cardiac failure and respiratory distress.

The sting results in an immediate, intense pain and the area around the wound becomes cyanotic (blue) because the toxin deprives the tissues of their blood supply. This explains the subsequent tissue necrosis found during the operation.

I met Caleb, sympathised with him on this unfortunate and horrible incident, and explained that I had never heard of it occurring on a film set. After examining his leg, we discussed how he could continue to film the interior scenes. This was going to be difficult, as a wheelchair would not get him around the narrow ship decks and companionways that had been created in the studio. We decided to suspend filming for ten days, after which time he should be able to walk around without further problems.

When I was with him, he talked about one complicated scene in the Seychelles that had taken two hours to set up. In many places in the Seychelles, the trees grow right down to the beach, giving the islands an uninhabited look when you travel round them in a boat. On this particular day, just as filming was about to start, the loud noise of a chainsaw started to come from the trees near to where filming was taking place. Caleb sent his assistant director onto the shore to find the source of the noise and to ask the wood cutter to stop for half an hour so that the sequence could be shot.

The assistant director returned to say that the wood cutter had been instructed by his boss to cut the tree down, and if he stopped, he would lose his job. The assistant director was then dispatched back to shore with $10 to give the wood cutter if he would stop for half an hour. The wood cutter duly stopped. The next day, there were half a dozen chaps with chainsaws cutting down trees adjacent to the filming!

That summer, George Panayiotou, aka George Michael, was in the middle of a major European tour, after performing in Australia, where he picked up a head cold. This continued to cause problems throughout the European tour, resulting in some lost dates over a four-month period.

During this period, I saw him at various times in London, Hamburg and in the south of France. He had a variety of ENT opinions and, in the end, had to have surgery, followed by a period when the tour came to a halt.

When singers have had an upper respiratory infection there is always a risk that they will develop a persistent swelling of the vocal cords. At worst, they develop a nodule on the vocal cord that prevents the vocal cords from meeting correctly. This makes the voice raspy and hoarse, making singing impossible. Therefore, surgery is required to remove the nodule.

Some singers have vocal cords that never properly join up, resulting in a specific hoarseness that gives them a distinctive sound. Rod Stewart and Louis Armstrong are prime examples of singers with very successful careers because of their distinctive voices.

It was the end of September and Jenny Seagrove was involved in two productions, *Magic Moments* and *Some Other Spring*. I had been asked by insurers to do pre-production medicals for both productions. I had heard a rumour that she was seeing Michael Winner but, tempted though I was, since there was some doubt in my mind, I did not feel it appropriate to ask if she knew why Michael kept a whip in the hall at his house.

*

In the same month, I visited Marlon Brando, who was staying at a hotel in Notting Hill. He had been cast as a lawyer in *A Dry White Season*, a film about the injustices of apartheid. He had not turned up for his first day in front of the camera. When the unit driver arrived at the hotel to take Mr Brando to the studio, he was told that he was not ready. The driver waited for half an hour and then made contact again. This time, he was told that Mr Brando was "Not ready and would not be all day."

At the hotel, I had a long consultation with Marlon, during which he rambled on for an hour and a half, talking about a number of problems which had made him tired and unable to attend the studio for the courtroom sequence that was scheduled to be filmed that day. He mentioned that he had arrived in London four days earlier and had two days of rehearsals for the courtroom scenes. He also told me that he had lost 20 pounds in the previous two weeks, on a diet of fluids, fruit and the occasional baked potato. He continued to discuss other problems, which were particularly centred around a friend of his sister's, who was his psychoanalyst. He told me that he had not acted for seven and a half years and now, in fact, disliked acting. He was unhappy with the script, which he had been rewriting over the last four days. Two days earlier, following studio rehearsals, he had had his hair dyed, during which he was so tired he had fallen asleep. The rehearsals were hectic, and he had noticed that, unlike the other actors, he was sweating. He realised that he was still overweight and had been leading a sedentary existence. This caused him to worry that he might be at greater risk of a heart attack. Finally, he told me that he had learned the previous day that a boat carrying a considerable shipment of oil had been swept into the lagoon of his island. There was a risk that the oil would spill, and this too was causing him distress.

I checked him over and reassured him that there was nothing abnormal. We continued to talk and he asked me a little about myself, and how I had become a doctor and how I had become involved in the film world. At one point, he asked me if I would like some refreshments, and I said that I would like some tea. He kindly ordered this, and some water for himself. I noticed that he was rather abrupt with the woman who brought our drinks, which reflected his general mood. Before I left, I told him that I would keep in touch to see how he was getting on.

I then went to a meeting with the producer and director of the film, and the insurers and loss adjusters. The director, Euzhan Palcy, explained that she had met Marlon Brando in Hollywood and had outlined her film to him and how it explored the injustices of apartheid. This fitted in with his desire to help disadvantaged people, and so, he had agreed to act in the film for no fee. He expected his expenses to be covered, and requested that the production company, MGM, make a donation to an anti-apartheid charity.

The production company then admitted that they had not contracted him. This was clearly an oversight. In the current situation, they were presented with a potentially unsolvable problem since, without a contract, they could not force him to work. They had, however, taken out cast insurance cover, and if he was unwell, they could potentially make a claim for lost time on that policy.

All eyes turned to me, since quite a lot was hanging on my diagnosis.

I paused and said, "I don't think that he has any particular condition. He has a number of concerns which he shared with me, but I think that his statement to the unit driver 'that he is not ready' is accurate."

A discussion ensued, the outcome of which was that all parties requested that I visit him every day until he was 'ready'. Clearly, there was the possibility that I could put some medical label on his condition, which would clarify who would pay for the delays to filming. Alternatively, I could listen to his various worries and, having unburdened himself, he might feel able to return to the studio.

The next day, I visited him in his hotel again. He was pleased to see me and, after discussing his medical concerns and checking his blood pressure, and so on, we settled down to a long chat. This covered some of the same issues that had been raised the previous day, but we now wandered into new pastures, some philosophical and metaphysical. Occasionally, I might use a word that he was unsure of. To be sure of its meaning, he looked it up in the Oxford English Dictionary.

He questioned me on my reasons for going into medicine, and I explained my interest in science and involvement with people, harking back to that statement I had made 30 years earlier as a precocious schoolboy. He again asked me how I had become involved in the medical side of movie making. I explained how, as a medical student, I had acquired an Equity card and my involvement in *A Man for All Seasons*.

He was interested in my observations on how Paul Scofield prepared for a scene, and of Leo McKern playing Oliver Cromwell, as Leo was also acting in *A Dry White Season*.

He started to talk about how much he admired the English way of life, and he mentioned that he thought he might buy a home in England. He asked my opinion on a suitable area to buy a house, and we had a discussion around what his priorities would be, such as a rural setting, privacy, how many bedrooms, and so on.

He meandered on to say how much he admired traditional English classical drama training, and institutions such as RADA, the Central School of Speech and Drama and LAMDA.

He then explained his background with Stanislavski and the Meisner technique, which was something that I knew nothing about. He never used the term 'method acting', which was the way his acting technique was always described by commentators.

He changed the subject to the length of time since he had last acted and mentioned *Superman: The Movie*. I was able to tell him of my involvement in *Superman II*, and the back moulds for the flying sequences that had caused Jack O'Halloran to slip a disc.

He then drifted back to talking about the classics and the Royal Shakespeare Company. I wondered if he was so admiring of classically trained actors, such as Michael Gambon, who was playing the magistrate in the courtroom scenes, that he had developed 'stage fright'.

I had a further meeting with the producers and the insurers and had to tell them that, although Marlon was not ill, he was still 'not ready'. I felt he might be ready in a couple of days, but I couldn't be certain.

I had begun to conceive a therapeutic intervention, which I hoped would help Marlon regain his performing confidence. I left the meeting and went home to prepare for the following day.

At home, I carefully packed my medical bag, inserting a few items that were not medical instruments, but were part of my attempt to build Marlon's confidence about performing.

When I arrived at the hotel the next morning, he greeted me warmly and told me how much he enjoyed our meetings. I suspect that some of this had to do with his seeing me as an archetypical

Englishman in a suit, white shirt and tie, and polished black shoes.

We swiftly resumed our wide-ranging dialogue and, again, from time to time, we looked up the meaning of words in the Oxford English Dictionary. 'Impartiality' and 'reconciliation' were checked. He also mentioned that he had been up late the previous night rewriting his lines for the courtroom scene, and I felt that this engagement with the screenplay was a positive sign.

After a while, I disclosed that I had been in the Magic Circle at school, and that I had given a performance to a full audience in the school library. I then took four tricks out of my bag, which I performed, much to Marlon's amusement. He asked me how I had done the tricks, and I explained that one of the rules of the Magic Circle was that you only divulge the secrets behind tricks to other magicians. I continued by saying that I would teach him two of the tricks if he would learn to do them himself and then perform them. He agreed and, having learned the two tricks, performed them back to me with a performance that only Marlon Brando could have created.

The previous two days, we had ordered tea and biscuits and bottles of water from room-service. I had requested Earl Grey in preference to English Breakfast, which I told him was also called 'builders' tea'. This greatly amused him. I suggested that he try out the tricks on the person who would shortly bring our tea and biscuits. As it so happened, the woman who brought our tray was the same woman to whom Marlon had previously been rather abrupt. He apologised for having been short with her and asked her to sit down while he did something to compensate for his previous poor behaviour. He then showed her the tricks he had learned, after which she applauded enthusiastically. I could not

help noticing the pleasure that was clearly registered in his smile back to her. When she left, he asked me if he had done alright, and I was positive and enthusiastic in my response, particularly about his performance.

We chatted on, and at the end of the meeting Marlon announced that the next day he would be 'ready'.

I reported to the producers and insurers that I was confident that Marlon would turn up for filming the next day, which he duly did. There were no more delays to filming, and he and I chatted on the telephone from time to time.

Subsequently, he was nominated for an Academy Award for Best Supporting Actor for his part in *A Dry White Season*.

In an epilogue to this saga, several years later, Marlon asked me to go to Ireland to see him. He was there to play a mystic priest in *Divine Rapture*, and the stellar cast included Debra Winger, John Hurt and Johnny Depp. I visited him in a beautiful Georgian house that the production company had rented for him. When I entered the house, I was taken to the drawing room where I found Marlon lying on a chaise-longue wearing a pale kaftan. He was listening to a recording of someone speaking with a strong Irish accent, and he switched it off so we could talk. We greeted each other and caught up on our news. Sadly, since our last meeting, Marlon's daughter had died.

He had also put on a lot of weight, but his examination did not reveal any medical problems. He voiced his concerns about the financial status of the production and revealed that he had asked to be paid $1 million in advance. He told me to be sure that someone other than the producers would be responsible for my visit and my expenses.

As I was leaving, he accompanied me to the dimly lit corridor, off the hall, leading to the front door. He asked me to wait a moment, and then showed me two new magic tricks he had learned. He was clearly delighted to be able to demonstrate his conjuring progress to his erstwhile magician mentor. Naturally, I applauded.

I left to see Debra Winger, John Hurt and Johnny Depp. Finally, as I said goodbye to the producer, he opened a drawer in his desk and gave me two large cigars with *Divine Rapture* printed on the metal wrappings.

At the end of the week, production was halted due to lack of funds. When the producer contacted the funders in America, his enquiries ended up in an empty office adjacent to a public car park. Marlon got his million, I was paid and got my two cigars, and nobody else received a penny.

I felt sorry for the hotel where the cast and crew were housed, and for all the other suppliers, such as the taxi drivers who had become the unit drivers. There was no way for the film to be refinanced, as the rights to the story could not be transferred to a third party in time to prevent the cast scattering far and wide to start work on other projects. Those two weeks of filming are probably sitting in a can somewhere, gathering dust.

Somewhat later, Jimmy Nesbitt told me that it was his distinctive Irish voice that Marlon had been using to perfect an Irish accent. Marlon was friendly with Richard Harris, whose son Jared was at drama school with Jimmy. Jared had recommended Jimmy as a typical Irishman. I suppose Jimmy is that, and he is also, for his sins, a Manchester United supporter.

*

On 20 September, I travelled to Spain, where a production of *The Return of the Three Musketeers* was being filmed, with Roy Kinnear playing Planchet.

Filming was taking place in Toledo and there was a riding sequence in which the three musketeers rode ahead of the plump and short Planchet riding a short and plump horse. Roy Kinnear followed the others across the Alcantara Bridge over the River Tagus. The lead horses turned left and out of sight, causing Roy Kinnear's horse to panic and skid on the cobblestones. Roy was dumped straight down, landing on the ground directly on his pelvis. As he lay there in great pain, he bravely turned to the director, Richard Lester, and asked whether the shot had gone well.

The Spanish crew had misunderstood the director's instructions and had watered the cobblestones, making them extremely slippery, and, to give them an authentic period look, had covered the wet cobblestones with sand. Before the take, Roy had only one 15-minute practice on the horse. In addition, a number of key members of the unit, who could have advised on what could go wrong with the shot, were not present. As any horse stuntman knows, a horse following other horses that go out of sight will try to pick up pace to catch them up. On slippery cobblestones, this was going to cause problems. If an actor, unaccustomed to horse-riding scenes such as this, is suddenly jolted, he will not instinctively know how to react. Looking at the filmed footage afterwards, it was clear that Roy had lifted himself out of the saddle and dumped himself down onto the cobblestones.

He was taken to Toledo Hospital and, from there, transferred to Madrid, to the Ruber International Clinic. An X-ray revealed

no 'serious' fractures, but noted a separation of the pubic rami, the bones at the front of the pelvis. During the hours following admission, it was noted that his blood pressure was dropping. It was concluded that he was suffering a cardiac episode and ECGs and an echocardiogram were performed. They applied a defibrillator, but he continued to go downhill and, by the time I arrived at the clinic, he had died. The subsequent post-mortem revealed that his coronary arteries were normal and he had no internal organ damage, but there was huge blood loss into the pelvic cavity. The cause of death was given as 'traumatic shock'.

Having trained in orthopaedics at St Thomas', I knew that the greatest risk of certain pelvic fractures is intense internal bleeding. I asked for the measurement of the separation of the pubic rami and was told that it was over 5cm, which meant that the sacro-iliac joints at the back of the pelvis were well and truly open. This would have caused significant internal blood loss which would have required large volumes of intra-venous fluids and blood transfusions. But he never received these. I decided to request a second post-mortem once Roy's body had been brought back to the UK, as I felt sure that his family would want closure with the correct cause of death. They would also want to investigate the circumstances that had led to the fatal accident.

I flew back to Heathrow, where I was met by members of the press who were anxious to get a quote from me. The gist of my comments was reported on *News at Ten* that night:

"I have yet to complete my investigations, but I am not entirely convinced that I have the details necessary to form an opinion on what followed after the fall. However, I can say that Pierre Spengler, the producer, and the unit doctor acted with speed and responsibly ensured that the best available medical care

was arranged for Roy Kinnear. I hope to be able to have a clearer picture of the medical details in a few days' time. We have sadly lost a man whose talents were to spread happiness to all he met, as he always did in his visits to me."

I continued:

"I will, as always, try to ensure the safety of actors, actresses and stuntmen in films, and what comes out of my investigations can only be of benefit to others. Film-making can be dangerous, but accidents like this should never happen."

The second post-mortem confirmed that the pelvic split had caused significant internal blood loss, from which he had died. It was a terrible tragedy that resulted from a chapter of errors.

In October, I went to Pinewood Studios to see the actress Sean Young, who had been cast as Vicki Vale in a large Warner Brothers production of *Batman*.

She had started taking riding lessons at Pinewood in preparation for the start of principal photography on 15 October. On her second riding lesson, on 11 October, as she went out of the schooling ring, the horse bolted round a corner, throwing her to the ground. She fell badly onto her left shoulder. Subsequent X-rays revealed a sub-capital fracture through the surgical neck of the humerus, the bone of the upper arm. She was put into a sling, since the fracture was impacted and therefore stable, and did not require surgical intervention. She was to wear the sling for a month and then proceed with further mobilisation as the pain on movement settled.

Sean found it difficult to accept that she would not be able to take part in the film. She said that she could manage the pain and limitation of movement. However, it was clear that this was

not going to be possible, but it was some time before she accepted the situation and agreed to go back to the US. In retrospect, I wonder how much riding experience she had and, if her level of experience had been known by her riding instructors, whether this accident would have happened.

The part was taken by Kim Basinger who, luckily for Warner Brothers, was available.

Some years ago, with the aid of a top stuntman, Jim Dowdall, I gave a talk to the British Performing Arts Medicine Trust. This is what Jim had to say about horses, after I had described the accidents involving Roy Kinnear and Sean Young:

"Well, horses and cobblestones are really a bit like petrol and matches to me. I have just finished a film, which is the Jekyll and Hyde story, but considerably embellished, starring Julia Roberts and John Malkovich. There is a sequence in which both John and Julia are supposed to be running down a sloped cobblestoned street, while being pursued by two mounted police in Victorian kit. The producer glibly said to me, 'Right, we will just get a couple of extras on the horses and it'll be fine.'

"I replied, 'We're asking for trouble here. There's no way I'm going to have Julia being paid $9 million for the picture and having a horse fall on her.'

"I got both the leads doubled and got stunt people on the horses. I had the horses shod with titanium nails, which cling to cobblestones and, in addition, give quite an interesting effect because they sparkle. I would not let John or Julia anywhere near those horses. As far as Roy Kinnear was concerned, this is rather 'closing the door' (pardon the pun) too late to ensure that similar precautions were taken for him. He should never

have been near that horse, there is no way he should, and the stunt coordinator wasn't even around. If he had been around, he'd have pulled him off that horse and got a stunt double. But it's a classic thing: animals, they bite you at one end and kick you at the other, and in the middle it's about a pea-sized brain, even in a horse, and they're extremely unpredictable, whether it be horses or big cats. I've worked with big cats in the circus, and there is no rhyme or reason to their behaviour. A friend of mine was attacked. Every night after the show, we would put the cats away, feed them and settle them down. On one occasion, there was a thunderstorm. It was a beautiful clear evening, no problem, the guy's walking past the cage and a cat comes for no reason at him across the cage. He ended up with 164 stitches down the arm, for no reason at all. So, animals and actors, I don't like the mix at all. I really think it's a dodgy game."

Now Jim was on a roll, and he went on to describe a fire stunt.

"I was in Italy, doing a job for an Italian director. It was a fire job. In the sequence, a petrol station is set on fire, and the guy at the pumps is aflame from head to toe. I use a system – well, I did in those days before I knew better.

"I said, 'Fine, I'll keep waving my arms and moving around, and if I start to get into trouble, and I start to get hot, I will make the sign of the cross, okay, and if you see the sign of the cross you come in and pull me out.'

"So, the thing goes off – 'bang', it's on fire, and I think I'm getting a bit hot in there. I make the sign of the cross, and the guy, the prop man who has been told to go in (we'd rehearsed the routine of pulling me out), starts to go in to get me, but the

director grabs him and says, 'He looks great, he's doing fantastic, leave him.'

"That cost me a week in hospital with, you know, first- and second-degree burns. So, having knocked the director out, I got on a plane to come back to England. Now I always insist that I have a stuntman and a safety man with me. If they want to do a full 'fire burn' I say that you can pay for this other man to put me out, because I will never trust anyone else, a fireman or whoever it is. I know the only person I can rely on 100% is that particular stuntman because he has been in the same situation. He is the guy that says, 'To hell with you. He's in trouble, I'm going to get him out.'

"It is a callous business. We are in a business where we are making entertainment. It is an incredible business. You shine a light through a bit of moving celluloid…and you can make people cry, you can make people excited, all these emotions, and that is an incredibly powerful medium. At the same time, it is still a piece of celluloid, and I sometimes question the fact that we do these things merely to project life through a bit of celluloid, and people sit at home and say, 'Oh, I think I'll have a cup of tea. There's a blazing fire on the screen. I've seen that before.'"

Jimmy then took questions from the audience.

The first person said, "My only question is, why do you do this?"

Jimmy replied, "I think principally because we are un-employable. I left school with one O level, joined the circus, and did all that sort of stuff. I am totally unqualified for anything.

"The things that I am good at – shooting, falconry, martial arts, parachuting – the kind of stuff that you have when you come out of the Parachute Regiment, having got those sorts of things

under your belt, you go for a normal job and they say, 'What are you good at?' and you say, 'Well, I'm quite good at unarmed combat and I can jump out of an aeroplane.'

"And they say, 'You're not quite what we're looking for.'

"Some of the younger people in our business come in and are incredibly dedicated. They have worked for three or four years to get the qualifications that we require. But for most of the older ones, like myself, we come from backgrounds in the circus, the rodeo, we parachute, we joust, that sort of thing. We used to joust in the City of London Festival in the seventies when that was popular.

"We went around America doing it, because we could ride horses and use swords. We thought, 'Well, here's a way to make money.'

"If you put the majority of us in a pot, you would not pull out more than about six academic qualifications."

In late June 1988, I saw my tennis friend, Annabel Croft, who was appearing on some tennis TV show. From her continuing ability on a tennis court, I knew she was extremely fit. I had been playing some fun doubles at Queen's Club with Charles Benson, the racing correspondent for the *Daily Express*, Johnny Francome, National Hunt champion jockey, and Annabel, the British No. 1 tennis player. Rather foolishly, I had then fixed up a game on my own with Annabel on the grass courts. The only way that I could survive was to serve big and follow up with a volley. There was no point in trying to rally with her from the back of the court. So, I was coming in and diving all over the place to get her returns. After my game had being taken apart by her, I went to the dressing room and was having a shower, when I felt a lump on

my right lower abdomen. An inguinal hernia: that would teach me to play singles against the British No. 1.

I recently got my own back on Annabel. Her daughter is a very good friend of my niece, Marnie, as they both attend Wellington School. Recently, Marnie introduced me to Annabel's daughter when they were both at our London house.

"Uncle Johnny, this is Annabel Croft's daughter, and Annabel has told her that she knows you."

"Yes", I replied. "Your mother and I were having some fun at Queen's Club one afternoon many years ago and, as a result of my falling around on the ground, she gave me a hernia."

They both looked at me in horror, followed by a girlie giggle. "Oh, Uncle J…"

In March 1989, Eartha Kitt came to see me before starting a three-week run of her one-woman show at The Shaftesbury Theatre. She had been worried about her voice but, by opening night, she had no vocal problems. On 12 March, about two hours before the show's opening night, her assistant rang me in a state of panic. She had gone to Eartha's hotel to find the singer considerably the worse for wear, shaking and saying that she was terrified to go on stage. The assistant asked me what she should do. I suggested that she wrap Eartha up, because it was a chilly night, bundle her into the back of a taxi, take her to the theatre and settle her onto a couch in her dressing room. I would leave home and meet them there shortly after they arrived.

When I entered the dressing room, there was panic on the face of the assistant, and Eartha was shaking and coiled up in a foetal position on the couch. I asked for large cups of strong black coffee, and we slowly persuaded Eartha to drink these. I had

brought some multivitamin injections with me, including vitamin B12, which I had found to be a useful pick-me-up for some artistes.

I assured Eartha that the injection would make her feel better, and the caffeine was beginning to overcome her sedating, alcohol-induced lassitude. But she was still suffering from a high degree of stage fright, and I spent the time before the show assuring her that she was a great star and that the audience would love her. As showtime approached, she was persuaded to get into her dress, put on her wig, and apply her make-up. I left her to do this with her assistant, with the parting words that I would be at the back of the auditorium, and could she please sing for me.

I wandered out into the auditorium, and hoped that we had done enough and that there would be a show. The orchestra started playing, the curtain went up, a spotlight lit up the curtain at the back of stage right, and on walked a star in a beautiful tight-fitting dress, in high heels and holding a microphone. She started singing, or rather purring, as she moved slowly to a stool centre stage where she sat and crossed her legs, singing all the while. For me, this was mesmerising. I had left a frightened little lady in her dressing room, and here was a star absolutely at the peak of her powers. She sang 'Just an Old-fashioned Girl', 'Let's Do It', 'Love for Sale', 'C'est si Bon' and 'Je Cherche un Homme', among many other memorable songs. Throughout her run at The Shaftesbury Theatre she played to packed houses, and every audience had a treat.

In early June, I visited Dustin Hoffman at his London home in Kensington. This was a rather surreal visit, as it was the house I had lived in from 1976 to 1986, when Dustin bought it from me on the recommendation of a mutual friend. When he came to

look at the house, I remember he went into the laundry room on his own, as it was rather small with room for only one person. I could hear from rattling around and, when he came out, he had a dissatisfied look on his face.

"This won't do at all," he said.

The sale was clearly in trouble.

"What's the problem, Dustin?" I asked, nervously.

"I stood on the scales in there and they weighed me heavier by four pounds than my normal weight."

Sale still on then!

He had since removed our traditional wooden kitchen and installed a contemporary custom-built version. Otherwise, the house still had the same layout and feel.

I have a photograph of Dustin signed "Nice House", and he had a letter back from me starting "Dear Great Actor".

In July, Davy Jones was on a tour of Britain with The Monkees. He was performing in Carlisle and, for some inexplicable reason, decided to exit stage left rather than stage right, as he had done in all previous shows. Thinking that there was a set of stairs leading from the wings, he fell into a dark void and badly injured his left leg. He continued the show in great pain, but had to cancel future shows. Fortunately, there was no fracture, just a huge bruise that was causing him considerable pain. There was little I could do, other than confirm that the insurers had a claim on their hands.

This was not the first time I had dealt with performers tripping over something in the wings or falling off the stage. Show business can be dangerous at times!

*

In September, Chaka Khan came to see me having visited me through the recommendation of a friend. She was due to go on tour and wanted to run over a few things. She brought me some gifts, which was typical of this lovely lady, who had recorded several enduring and memorable hit songs.

10

Some private life

In March 1989, I met a gorgeous 25-year-old blonde, who was a nursery school teacher and a singer. I immediately asked her to accompany me to the Royal Opera House to hear Plácido Domingo sing. As she certainly was not expecting the invitation, she pretended to check her diary, and then invented a previous engagement. But I had already seen the blank date page in her diary and so she had no excuse to turn down my offer. This was the first of many events with friends and visits to the opera. We shared a love of theatre and music and it was not long before we became engaged.

I had been married in the mid-1970s, but that had, sadly, ended by 1985, with Dustin Hoffman buying our house following our separation. We had two sons, Justin and Toby, and it was a

difficult time for them, as it always is in such situations. I was deeply concerned about this and felt extremely guilty about what we were putting them through.

I went to see Dr Margaret Reinhold, the lovely psychiatrist author of *How to Cope with Your Mother*. This was not simply to manage the grief and sense of failure that I was feeling, but to look at how I had married someone with whom I could not have a lasting relationship. I was determined to learn from the experience and to ensure that I avoided making further mistakes in the future. My wife had a very complicated family background, and both of her parents seemed to have had issues. She was an only child and had had to learn to cope on her own from an early age. I knew this when we married, but thought that my secure family background and coping skills with patients would be enough to help her overcome the issues that had resulted from her upbringing. Confusing what happens in the consulting room with my home life was a definite error and something I could not let happen again. Friends were introducing me to single or divorced women, and I was keen to avoid the damaged and the needy.

Nicky, I quickly discovered, phoned her parents and her sister on a regular basis and there was clearly a strong loving family in her background. That box ticked then.

I recall travelling with her down the M4 to her family home in Holyport to meet her parents for the first time, both of us feeling rather anxious that this should go well. I was clearly under the spotlight. I sidled up to her father, who was busy with the barbecue, and tried to make some appropriate small talk. It was gibberish, and I stuttered out some stupidity in my nervousness. Her parents quickly put me at ease and, several visits later, I knew that this was the family that I wanted to be part of.

I kept telling myself that after the whole process of the divorce was over, there would be the compensation that I could help those patients who were themselves going through break-ups. This was indeed the case, and having worn the T-shirt, I was able to share my experience with them, and this added another very useful dimension to my consultations.

Before meeting Nicky, I had bought a double-fronted Georgian house in Old Church Street, Chelsea and had set about building an additional room at the back.

This required an architect, architectural drawings and planning permission. By October, I had all of this in place, and 'Bill the Builder', a large jolly Irishman, set about digging the foundations for the new room. Four metal rods were to be inserted in place in the foundations to which the structure would be fixed. As the existing Georgian building was an irregular distance from these rods, the architect sent his assistant down to ensure that the rods were all in the correct position. Thin and efficient, with his jacket neatly buttoned up, clipper board in hand, the architect asked Bill and I to measure the distance from the back of the existing building to each rod. As we shouted out each distance, the assistant noted it down, and at the end he compared our figures with the plans.

"The distances as measured are exactly those on the plans," he said, with more than a hint of surprise.

Bill looked up and replied, "Sure, 'tis a fierce accident."

On another occasion, I remarked that we had been very lucky with the clement and dry autumnal weather, and that in most years he would have been digging around in mud.

Bill replied, "So, you could say we are having an Indian summer, but widout de' Indians?"

I lived in the house with the works going on around me, and this provided me with a project while getting myself back on my feet after the breakup of my marriage. I was happily installed and comfortable when I met Nicky, but we decided that we should rehouse ourselves in something more suited to a family than a precious bachelor pad Georgian house.

Naturally, Nicky's initial screening of the 42-year-old doctor with two young boys had included asking, "Are you happy to have more children?" "Yes, of course, darling," I replied. With that hurdle cleared, my house was featured in a *Mail on Sunday* article about my film work, which added that the house was going on the market. The economy was not in great shape, and the housing market was slow, but the *Mail on Sunday* article secured a sale.

On 2 December 1989, Nicky and I had a blessing in Bray Church, followed by a reception at Nicky's Frizzell family home, Chuffs, in Holyport. My best man was Tim Simond, a friend since my days as a medical student. He and I spent the evening before the wedding at the Riverside Inn, Bray. Since I had been married before, we had to have an official wedding in Maidenhead Town Hall, which proved to be a surreal experience owing to an electricity blackout. We just about managed to hold it together without laughing through this rather curious event in near darkness. As Tim and I were making our way back to the car, we were told that we could go back to Nicky's family's house, since she and I were now officially married. There, we were joined by hairdressers, bridesmaids and caterers. My new father-in-law, Colin, invited Tim and I to join him in his study for coffee. He picked out a video cassette and we watched Tommy Cooper at his best. At some point, Nicky appeared, her hair in a state of preparation. She was shocked to find us howling with laughter

at Tommy Cooper's simple humour. We have not been allowed to forget it to this day. What did she expect us to watch? Some suitable romantic comedy? Possibly, but certainly something more in keeping with the solemnity of the occasion.

The blessing was really a full wedding dressed up as a blessing, and the bride, needless to say, was ravishing. At the reception, Nicky's godfather, Michael Graham, made a speech, in which he remarked that he had been surprised to see me wearing pink socks when he had taken us out to dinner. Tim roughed me up, as every Best Man should, insinuating that there were a multitude of different activities taking place in my practice, such as involvement in certain interesting investments that he purported had come my way.

Among the guests were Willie and Celia Whitelaw. I had known them since 1980 and we were good friends. In the early 1980s, Willie had been Home Secretary, as difficult a government post as any. In June 1981, he had to deal with riots, and handled many other unexpected events that no minister can prepare for. I remember discussing with him that I had noticed a rise in heroin abuse among my patients, and when I saw him next, he told me that the Commissioner of the Police assured him that it was not a major issue. I reiterated my concern and, a month later, he told me that the London Metropolitan Police had admitted that there was, indeed, a problem.

In 1983, Willie received a hereditary peerage. Around the same time the speaker of the House of Commons, George Thomas, was made the hereditary Viscount Tonypandy. Tonypandy had no children and Willie and Celia, having four daughters, had no heir to the peerage. They were, I think, the last to be made hereditary peers.

Willie was made Leader of the House of Lords, and it was in this capacity that he was involved in a Commonwealth constitutional crisis in July 1986, which resulted in a meeting with Mrs Thatcher and the Queen, during which the three discussed an appropriate way forward.

In 1987, while attending a service in Westminster Abbey, he had what appeared to be a stroke, and was taken to Westminster Hospital. I visited him early the next morning and found him sitting up in bed eating breakfast, with no stigma of having had a stroke. His speech was normal and he had suffered no loss of limb movement. All of this was excellent news.

I sat down on a chair by his bedside, and he paused for a long moment before saying,

"I woke up early this morning, and wondered what you would say when you came to visit me."

"Willie", I said, "I also woke up early and thought hard about how our conversation would go, and I have decided that, if you were my father, I would not want you to continue with the day-to-day stress of frontline politics."

"I thought that you might say something like that, and since we had an arrangement that you would tell me when it was time to step down from a Government role, I shall have to tell Margaret. But I am fairly sure that she will try to dissuade me."

He was right, as a few days later, I had a telephone call from Mrs Thatcher, reminding me that Willie had made a full recovery, and there was no reason why he could not continue as Leader of the House of Lords. I stuck to my position, but, unfortunately, did not have the presence of mind to tell her that "the doctor is not for turning".

Willie continued to give speeches, play golf and have shooting

parties at his house, Ennim, in Cumbria. On one such shooting weekend, I travelled up to Penrith by train with Willie and his security guard, on the Friday before the shoot. The security guard, incidentally, doubled as Willie's loader while shooting. We were walking down the King's Cross Station platform when a lady came up and started to rant at Willie about some government policy. He listened politely to this rather persistent tirade and, when she had finished, he simply said, "Now there's a thing," and walked on. I marvelled at his simple handling of an unwanted verbal attack.

At Penrith, we were met by the station master, and he and Willie chatted for a minute or two. I also saw that when members of the public spotted him, they generally smiled. He was a popular figure and one of very few politicians whose exit from politics was not due to their political downfall.

Once at their house, Celia would organise supper, after which we would watch the *News at Ten*. This was always an entertaining part of the evening. When someone made a political statement that Willie did not approve of, he would harrumph, and say, "Bloody fool."

Dinner on Saturday after the shoot was always a traditional formal affair in smoking jackets. Celia would escort the ladies out after the pudding course, and the men would move down the table to the end where Willie was seated. There were often other cabinet ministers present, so conversation would turn to what had taken place in the previous week. As you may imagine, I found this fascinating and one of the things I learned was that, early on, the members of the cabinet discovered that Margaret took her shoes off when conducting meetings. The schoolboys could not resist this and, at a subsequent cabinet meeting, they kicked her

shoes around under the table and Margaret had to stumble around in bare feet at the end of the meeting, much to their amusement.

Celia organised the Parliamentary Ladies Committee to raise funds for the Westminster Hospital, among other things. Evening events were held in 10 Downing Street, The Speaker's Office and elsewhere. She and Willie were very much a unit, and I admired them both for their sense of public duty.

Several years later, when Willie started to get confused while speaking, two of his daughters came to see me. I thought they wanted to discuss their father's health but, in fact, they were worried about the distress that his loss of cognitive function was causing their mother.

One of them said, "You have to understand that our father is our mother's creation."

II

The noughties

When Nicky and I decided to sell the Old Church Street house, we were lucky to find a wonderful family house in need of updating in Upper Cheyne Row. While the building works were going on, we stayed in the house of the film director Roland Joffé, just off Glebe Place at the back of Cheyne Row. Roland was in India, filming *City of Joy*, and when he learned that we were going to need somewhere to stay, he kindly offered us his house. He wanted no rent as he said he was glad to have someone looking after it while he was away. Roland's grandfather was the artist Jacob Epstein and many of his sculptures were in the main rooms of the house. I loved living with those sculptures for a few months and subsequently acquired an Epstein sculpture of the head of a young woman, which has a prominent position in my study.

Roland had cast Patrick Swayze, who had made his name in *Dirty Dancing*, in the lead role of Max Lowe in *City of Joy*. On 18 March 1991, Patrick suffered a blow to his right eye when he was hit by a rubber truncheon. The resulting corneal abrasion caused a 48-hour delay to production. Eye injuries were becoming all too common in the industry, and it was up to stunt coordinators to make sure that all those taking part knew exactly what they were doing, and the timing of their action. There should always be time for several rehearsals to reduce the risk of something going wrong.

I was sad to learn that Patrick died far too young, at the age of 57, from pancreatic cancer.

In late June 1991, I was contacted by the insurers of a Hollywood film that was provisionally called *Arrowtooth Tales*, but would subsequently be released as *Arizona Dream*. It starred Johnny Depp, Jerry Lewis and Faye Dunaway. It was being filmed in Arizona and directed by Emir Kusturica. Emir had started his career in Sarajevo television, where his documentaries had both provoked controversy and won critical recognition. His second film, *When Father was Away on Business*, won the 1985 Cannes Palme D'Or and his third film, *Time of the Gypsies*, won the 1989 Cannes Best Director Prize. As a result, Hollywood recognised his talent, and he was invited to teach on a film course at Columbia University, and then to direct a big budget film.

While filming in the US, Emir had become unwell, and had returned to his home near Sarajevo. It was arranged with insurers that I would fly to Sarajevo on 4 July to meet with Emir. In view of the potential for a large loss and any dispute over where liability might fall, I had asked a colleague to join me, to give a second

opinion. We were also joined by a Croatian producer, Branko Lustig, who represented the production company.

We met Emir in the Sarajevo Holiday Inn. Prior to the medical examination, we had an open discussion about the setting up of the film and the chronology of events that took place prior to his becoming unwell.

The film had been written in collaboration with one of his students at Columbia, and was commissioned by a French producer, Claudie Ossard. The initial budget was $8 million but, after script revisions, this was increased to $11 million. Even this was not adequate for the script as it then stood. At the end of January, Emir had started filming in Alaska with a non-union crew. At this stage, there was no completion bond insurance in place to guarantee that the film could be finished. The whole concept of guaranteeing the completion of a film was new to him, even though this was standard practice in Hollywood. Just prior to the commencement of filming, Warner Bros had demanded that 17 pages of script be cut, because they wanted a 120-minute PG13 film. Discussions about these cuts to the script continued until ten hours before the start of principal photography. As he was used to autonomy over his low budget art-house films, this was an unknown and trying experience for this sensitive and creative director.

Three days into principal photography, the film was shut down for 12 days for a rewrite, owing to further pressure from the producers who now wanted to cut 15 pages from the script, and ten days from the filming schedule. Again, there was no completion bond in place. A compromise was reached and, after intense pressure, Emir agreed to find five days which would be filmed last and could be omitted if the film went over budget.

Under pressure, he signed the new schedule, which allowed the completion bond to be put in place. He now felt that he had made a huge mistake in agreeing to the completion bond insurer's terms and wished that he had walked away from the film at that stage. He rather hoped that the quality of the 'dailies' would persuade the financiers to increase the budget to complete the film as originally scripted.

Emir described other aggravating factors, including time lost due to wind, Jerry Lewis only having the energy to work from 9am to 3pm having had cardiac by-pass surgery, and Faye Dunaway being, at times, difficult to work with.

As a result of these problems, and others which emerged later, he visited his lawyer in New York on 20 June, and shortly thereafter flew to Paris. From there he drove to his home in Sarajevo.

Emir's father had been a friend of Tito's, so he had an emotional vested interest in Yugoslavia remaining an entity. Trouble was beginning to brew in other parts of Yugoslavia, such as Croatia, where the Croatian war of independence had started three months earlier.

Emir had received a telegram from his director of photography, a Slovene, renouncing their friendship and announcing that he was taking up arms and joining the uprising. This greatly saddened Emir, but it was an indication of the splits that were about to occur.

The problem I was presented with was establishing whether the background to Emir's walking off the set was enough to establish a contractual problem between the production company and their director, or whether there was a medical condition that would shift the liability to the insurers. Following this general

discussion of the background with all concerned, my colleague and I went into Emir's medical background, and conducted an examination.

We all then had lunch, and it was decided that Emir had suffered sufficient aggravations that he should be granted a four-week break from production. Since filming had already stopped, it was now a question of securing the services of all the actors for longer.

As we ate, we discussed what was happening in Croatia, and wondered whether the same could happen in Bosnia. Branko Lustig was adamant that there was too much intermarriage between Bosnian families for a full-scale conflict to break out. Branko Lustig was a Holocaust survivor of Auschwitz and Belsen-Bergen and the prospect of another genocide must have influenced his thinking. The problem was that the population comprised Muslim Bosniaks (44%), Orthodox Serbs (32.5%), and Catholic Croats (17%), and the Bosniaks and Serbs would not see eye to eye.

Some younger Bosnians had already started to move away, as they saw what was coming. In retrospect, seeing this European country prior to that horrific conflict made a deep impression. So did our return journey, a month later. This time we went to Dubrovnik to get an update on Emir's state of health. It was the end of July, but the hotel was empty, with row upon row of empty deck chairs blowing in the breeze. The Siege of Dubrovnik started two months later, on 1 October. Many people were already aware that this was possible, so many had left, and tourists were no longer visiting. We were driven down the coast to Sveti Stefan, in Montenegro, where Emir was staying. We were joined by a representative from the completion bond guarantors, Film

Finance, who could well see that the involvement of his company might well be required to ensure that the film was completed.

We met in the Villa Milocer, once the summer residence of Queen Marija Karadjordjevic, beautifully positioned overlooking the Adriatic Sea.

Emir was now positive about completing the film and was in great spirits as he had spent much of his time playing tennis and football with his family. Before becoming a film director, he had been a professional footballer, and playing football still gave him great pleasure. The rest away from all the stresses of production had greatly helped him. He told us that he had been talking to his lawyers in New York and reiterated that he did not wish to be the victim of a financial mess. He understood that Branko Lustig had become involved in resolving the script issues and had prepared three possible schedules for film completion, and Emir was positive about this initiative. He looked forward to filming again and was focused on the good parts of filming, rather than the problems.

We cleared him fit to return to the production, and settled down to a glorious lunch with a beautiful view over the Adriatic Sea. It would have been a wonderful place to stay for a few days, but it was clear from the rapidly emptying Dubrovnik that a return to the UK that evening was the best course of action.

Another complicated actor-production company difference of creative aspirations was also brewing, and I was once again asked, on behalf of the insurers, to give an opinion on the actor's health. The actor in question was Gary Oldman, who had been cast to play Dylan Thomas in an HTV production.

Filming started on Monday 28 January 1991 in Wales. I had known Gary for some time and, on 5 February, he came up to

London with his wife Uma Thurman to see me. He was very concerned about the direction that filming had taken. He felt that takes were being rushed and the subject matter was not being properly covered. He felt that he couldn't do his job under these circumstances, and told me that on the preceding Monday, they had shot six scenes, on Tuesday, nine scenes, and no close-ups. He felt he was always being rushed to make-up, and the make-up artists had not seen the rushes, which would show them some of the issues that concerned him. He wore prosthetics on his face because, in the course of the film, he aged from a young 20-year-old to a rather ravaged 30-year-old and, on some days, he had to go from one to the other. He spent many hours in make-up, which considerably extended his working day.

A fight scene that should take all day, would end up being shot at 7pm, with most of the day having been spent on another scene.

He said, "I'm an actor who gets stuck in, rolls up my sleeves and gets on with it, and I am worried about what's on screen. I am not going to allow them to do this to the memory of Dylan Thomas. The rushes are awful."

He continued, "I went into this for a great experience and not to have to have an alibi at the end of the day. I'm too rushed to do a proper job. The director wants to do a piece of entertainment and does not give a f*** about Dylan Thomas. And the producer says, 'We are making a love story, but I do not give a shit about Dylan Thomas, and we are doing this story to sell to America.' The writer has used other people's material, and when forced to rewrite part of a scene, has produced very mediocre material, and I have lost all confidence in his ability."

He then said, "On Thursday, before filming started, it leaked out that they did not have the rights to his poetry and, at

that stage, I was in doubt about whether the film would happen, and wanted to pull out."

Gary saw two eminent specialists, neither of whom saw any medical reason for him not being available for filming. I had numerous meetings over the next three weeks with his theatrical agency and Duncan Heath, his agent, while the outcome of filming remained in doubt. On one occasion, the production company demanded an AIDS test for no sensible reason that I could see, without informing either me or Gary in advance. The pressure on Gary was intense, and it was a testing time for all. The production eventually was halted, and the film, to my knowledge, has never been made.

In January 1990, an 18-year-old girl came up from Wales with her mother and her nan as her chaperones. She was due to take part in a French film, *Resurgence*. I was impressed by the lovely close-knit family that she clearly came from. Her name was Catherine Zeta-Jones. Thereafter, she came on her own for medicals and, by August 1992, I was seeing her for *The Darling Buds of May*. This was a turning point in her career, and she became a well-known face. This had its drawbacks, as I now had to let her out through the back door of the practice to avoid the hoard of paparazzi waiting out front. Around that time, my wife and I were involved in a charity event, and Catherine kindly helped us by being there, much to the pleasure of all those who had paid to attend. Sadly, for me, as with Christian Bale, her success took her across the Atlantic to Hollywood, where she now lives.

Sir John Gielgud, by now aged 88, came to see me in October 1992, and I asked what was the driving force that kept him acting.

"Oh," he said. "It's for the boy." The 'boy' in question was Martin Hensler, his long-term companion who was in his seventies. This was not the real reason for his continuing to take on roles, as he loved his profession and was still in great demand. He also had a great memory, which continued until he died at the age of 95.

I knew that he greatly admired the writer Peter Ackroyd, who was a friend of mine, and I managed to put together a lunch at our house so the two could meet. As you might imagine, there was much cross questioning and badinage between them, which increased in intensity when Nicky and her sister left the dining room.

Johnny G, as we called him, had a fund of showbiz stories that we enjoyed, and I reminded him of a recent event during which one of my Garrick Club friends had met him in the WC stand-ups at a showbiz industry awards ceremony. My chum was wearing his club tie and, as they both stood having a wee, Johnny G, noticing the club tie, said, "Have you been in the club recently?"

My chum replied, "No, Sir John."

To which Johnny G responded, "They have done up the club's toilettes, and they are frightfully smart."

He continued, while looking down, "Makes one's old man look awfully shabby."

I still have a letter or two from him, with his precise writing sloped up at the end. In 1994 I wrote to Johnny G to congratulate him on having the Globe Theatre on Shaftesbury Avenue named after him. He wrote back mentioning the play that opened after the renaming of the theatre.

"I hear the Hall (Peter Hall the director) Hamlet is 4 hours, two and a half before the interval, and Hamlet strips off after

killing Polonius and cavorts with his mother on the floor!

I shall try to avoid going!

There is to be a small celebration On November 2nd in the morning. I shall be very content with that."

One of his memorable comments was his advice to a young actor on how to play Lear.

"Pick a light Cordelia"

In June 1990, Mel Gibson was at Shepperton Studios filming *Hamlet*, directed by Franco Zeffirelli. He was practising a sequence in which he had to twist, pick up another actor, drop him, and then jump from the stage to the floor level. As he hit the ground, he realised he could not move, due to the pain in his lower back. He subsequently saw a chiropractor who ordered a few days off work. I visited the set to see what action was being planned when he returned, and subsequently attended when he did. My wife was with me on that occasion, and all she could say as we drove back to London was that Mel Gibson had the most piercing pale blue eyes that she had ever seen.

In July, an accident occurred on the set of *Shogun Mayeda*. David Essex was in a scene in which a stuntman fired a flintlock pistol at close range. The powder shot hit David's left eye with such considerable force that he retracted his lid very rapidly. He sustained a laceration of the conjunctiva, which required suturing. This prevented him from performing for several days, but he was able to return once the visual appearance of his eye returned to normal. David had a helicopter licence, and using the readings from that medical, the ophthalmologist was able to establish that his vision had not been affected by the incident.

This is not the first gun accident that I have described and, fortunately, there was no lasting damage in either incident, but blanks fired at close range have great force, and are clearly dangerous.

In May 1991, Norman Beaton came in for a medical for the popular TV series *Desmond's*. The series ran for more than six years, was the most successful sitcom produced by Channel 4 and was arguably the funniest programme on British TV. Playing Ambrose Desmond in his Peckham barber shop wasn't the only string to Norman's bow. He was also a Shakespeare actor. We got to know each other well from his regular medicals, which were always fun due to his huge sense of humour. He was the doyen of Black British drama, and the forerunner of many actors who followed in his footsteps. Indeed, he played alongside a young Lenny Henry.

On one occasion, Norman asked me to a birthday party and, when he telephoned, he always started with, "Hello there, white man." He died in 1994 and a memorial service was held in a packed Southwark Cathedral. As a church warden walked past us in the aisle, I overheard a member of the congregation say in a loud whisper, "They have not had such a full house in years." This was true and the 'house' was served up a treat. The service was joyous with Caribbean dancing, singing from the London Community Gospel choir, and eulogies from Ram John Holder, Corine Skinner-Carter and Michael Grade.

At the end of June 1992, I saw Paul McGann, who starred in *Withnail and I* with Richard E Grant, and had been cast to play the title role in a TV series based on the Bernard Cornwell book *Sharpe's Rifles*.

I had seen Paul on a number of occasions for other productions and, in February 1988, he was filming at Elstree Studios when he was injured in a stage fight, taking a blow to his right ear. As a result, he felt faint, nauseous, and suffered from tinnitus. He had a small haemorrhage on the right eardrum, and diminished hearing. Fortunately, over the next few days, these issues settled completely.

For budgetary reasons, *Sharpe's Rifles* was being filmed in Crimea, near Yalta, and principal photography started on 10 September. Six days later, on a rest day, Paul and other members of the cast and crew were playing football, when Paul sustained a twisting injury to his left knee. He was initially put into a plaster cast, and then an elastic bandage and treated with physiotherapy. He continued filming but, on 29 August he was rehearsing a sequence that involved dragging another actor out of a tent, holding him up by the waist and throwing him to the ground. While doing this he again twisted his knee, and he was back to square one or worse.

On 6 September, I flew Yalta to see him on behalf of the film's insurers.

Back in 1992, getting to Yalta was quite a complicated affair. Ukraine had become independent from the USSR the previous year, but all flights still had to go via Moscow. In addition, Ukraine did not have fuel to fly planes from Moscow to Simferopol, the airport in Crimea, and nearest to Yalta. Therefore, the only way to get to Crimea was to take a train from Moscow Central Station. This 24-hour journey was broken by station stops, where women with baskets sold apples, the only food we had on that lengthy journey. On the train, all we were offered was weak tea. As the train slowly made its way south, we passed numerous sidings

with stationary and derelict railway carriages and vans. This was a country with outdated and failing infrastructure.

I was in the company of a loss adjustor and a member of the film crew, who as a keen chef, was looking forward to cooking fresh fish. Sadly, on arrival, there were no fish available for him to cook for us so no sea bass for dinner.

The production office was near the sea, in a building that had once been a Communist Party resort, with underground access from the building to the beach. There were posters on the walls for Communist events and International Trades Union meetings. Each morning, an elderly man came to a pillar box at the road entrance to the complex and sat there all day. He was a leftover of the Communist era. Nobody paid him, but that is what he had done for years, so it was what he continued to do.

I examined Paul at the primitive medical facility put together by the Communist regime. He had clearly sustained internal damage to his knee but, without CT or MRI scan facilities, it was difficult to know exactly what the damage was. I told him that sometimes a torn cruciate ligament and cartilage damage can settle down after the initial trauma, and satisfactory movement can be regained. He was reluctant to return to the UK for the appropriate investigations, since, given the travel options, the round trip would probably result in his being recast. He decided to stay and see if his knee would settle down enough to continue in the role.

I put together a clear set of instructions for managing his recovery, and had these typed out so that everyone concerned, including Paul, the director and the producer, had copies. The instructions included standard pre- and post-exercise regimes and, at the end, I added, "The ground of the location should be cleared, and Paul should pace out carefully his action."

On 13 September, Paul clambered up a very steep incline to take part in that day's filming. Some of the action involved diving into a bush and, at the end of the day, he started to experience swelling and further pain in the knee. Clearly, the knee was not going to settle on its own and I advised that he return to the UK for an arthroscopy. Following the arthroscopy, the surgeon was of the opinion that Paul had a 60% chance of returning to filming after a month.

However, on 2 October, I saw Sean Bean for a cast insurance medical, as he was taking over the role of Sharpe from Paul. The rest is history, as Sean was a huge success in the role and played it in several seasons as the production worked through the novels.

By May 1995, Paul had decided to seek compensation for having missed out on the role. He sued Sharpe Films Ltd, and I was mentioned in the action as an employee of the company. When I made clear that I was working for the insurers, I was added as a second defendant to the proceedings. I contacted my medical malpractice insurers and made it clear that I would not accept any negligence on my part. After I had presented them with all the clinical details and circumstances behind the claim, they agreed. Ten days later they came back to me, saying the claim was really against the production company, and it was, therefore, a commercial claim and they were not covering me. I told them that I had no commercial interest in the production and was just offering my services as a doctor to the film's insurers. Some time went by and I received no reply, so I rang one of the doctors on the board of the medical negligence company, who happened to be a good friend. He confirmed that the case had been discussed in a board meeting. I made it clear that I would finance my own defence and, at the end, sue them for costs and damages.

The film insurers offered no support, and neither did the loss adjustors, and both suggested that I should pressure the medical negligence insurers who, in the end, agreed to cover me. The sums were great and would escalate if this action ended up in court. An out-of-court settlement was agreed, and a sum was paid without my acceptance of either negligence or liability. This event was clearly unsettling and raised serious questions about my negligence cover when acting in the entertainment industry. The same was true of my work for The Queen's Club tennis tournament and, later, when I helped on the bench at Chelsea Football Club. After discussion with my insurers they agreed to allow me to continue with my existing policy, but with an increased premium to cover the higher risk of expensive litigation.

Paul has since said how sorry he was that I was dragged into the case, and the bittersweet end to the tale is that the person who kicked the ball to him during that fateful football game was none other than the film's producer.

I remained on good terms with the producers of *Sharpe's* and, in early November 1995, they were filming in Turkey. Daragh O'Malley, who played Patrick Harper in the series, was in a fight scene with another actor, Andrew Schofield, when the action went seriously wrong. While aiming to kick at Daragh's face without causing an injury, Andrew slipped and kicked Daragh's left cheekbone, fracturing the cheekbone and injuring the bone around the eye. Urgent surgery was required, which was performed in Turkey. Daragh then returned home, and I was able to discuss what had gone wrong to cause such a traumatic accident. He expressed considerable anxieties and concerns regarding the stunt action on the production, and told me that

they often did pieces of action without first rehearsing them. The stunt co-ordinator was not always present and fight sequences were often undertaken without being choreographed in advance. He had discussed this with his agent, who was requesting assurance that standard industry stunt practices be undertaken. As some of the other accidents I have recounted show, it is vital that a stunt coordinator is present to oversee and supervise stunt action. Too many accidents continue to happen.

In March 1998, poor Daragh was in the wars again. While filming *Sharpe's Peril* in India, a mini tornado caused a tent pole to lift from the ground and strike Daragh across the nose, causing a loss of consciousness. He suffered a broken nose, with an obvious deviation that required him to have corrective surgery.

When the *Sharpe's* series came to an end in 2011, Daragh decided to concentrate on his stage career, which was understandable in view of the horrendous injuries he had suffered while filming.

On 20 November 1991, I flew to New York to report on Whitney Houston's cancellation of performances due to loss of voice. The insurers were London-based and anxious to have someone from this side of the pond to ensure that the correct sequence of events was reported. I had flown to New York with he loss adjustor, Nick Adams and we both went to the consulting rooms of the ENT voice specialist looking after Witney Houston. The walls of his rooms had signed photographs of well-known opera singers and he was clearly the authority on singers voices.

Nick and I sat down and after the usual chit chat, and the reason for our visit, he leant back in his chair and said, "The problem, doctor, is that she cannot sing."

The problem, in his view, was that she had not had a formal education in singing and taking care of her vocal cords. It was, therefore, that same old problem of voice strain against another causative agent, such as an infection. In this case, there was also a pre-existing condition when the policy was taken out. Whitney's history was complex and, having reported, I left the untangling of liability to the loss adjustors.

I first saw Alec Guinness in the early 1980s, when he made such films as *A Handful of Dust*. He had made many memorable films with David Lean, including *The Bridge Over the River Kwai*, for which he won an Academy Award for Best Actor. His relationship with David Lean was not always straightforward, but they worked together again on *Lawrence of Arabia*, *Dr Zhivago* and *A Passage to India*.

Alec became a regular visitor to the practice, and I got to know him quite well. He had a very small group of friends, who he invited out to dinner when he stayed at the Connaught Hotel in London. He always insisted on paying the bill, because I think he liked to choose the location for the dinner and to be in control. His friends included Alan Bennett and Eileen Atkins. On one occasion, he told me that he felt very guilty about an altercation with another friend, Simon Callow. I suspect that, having converted to Catholicism, he resolved his guilt by going to confession.

We would share books that we had enjoyed, and he was fastidious in returning any book that I lent him, which is something that can't be said for all those to whom I have lent books.

Once, I noticed that Alec had nice italic handwriting, and when I showed him my Sheaffer ink pen, I asked if he would like

to try it, as I said that the italic nib might suit him. Initially, he declined, as he was concerned that he might damage the nib, but I insisted that he write with it. He was impressed and asked me where I had acquired the pen.

Two months later, he came to the practice, sat down and pulled out a brand-new Scheaffer pen.

"I have been to see your Mrs Hunter in The Pen Shop on Burlington Arcade, and this is the nicest pen that I have ever had. Thank you for the introduction."

Then he said, "Mrs Hunter told me an interesting story about a 16-year-old boy who came in one day, sat down and tried out a dozen pens, before finally settling on one. 'How much is this one?' the boy asked.

"When told the amount he said that he could pay half, and when he won the Marquess of Cholmondeley inter-school's handwriting prize, he would come back to pay the balance."

I obviously did not register, so Alec continued,

"You have forgotten? That boy was you."

I had a vague recollection of this, as we do not always remember the things we were involved in when we were young. Mrs Hunter's faith in my returning to pay would have been helped in no small part by my having been recommended to her by the Marquess of Cholmondeley, who had a lovely italic hand. I had already won the junior schools' handwriting prize, also sponsored by the Marquess, so there was a possibility that I might be able to secure the senior school prize too.

I continued to visit Mrs Hunter regularly over the years, to see if there was a pen with a nib that I could not resist. By then, my finances were in a better state, and Mrs Hunter was immediately paid the full asking price!

This incident helped to cement my relationship with Alec. He now had another special place to visit on his London trips to add to the Connaught Hotel, his barber and the select group of restaurants that he frequented. He was very particular about these and would countenance nowhere else.

I first saw Sean Connery in the early 1980s when he was filming his last James Bond film, *Never Say Never Again*. He had a flat only 500 yards from my practice, so I could easily visit him at his London base. He was a keen golfer, and a member of the Royal and Ancient Golf Club of St Andrews. I was introduced to golf in the 1990s by my father-in-law, Colin Frizzell, never having played before. With his encouragement, I started to play regularly and, after a year, I had a handicap of 22, of which I was rather proud. Shortly after achieving this, Sir Rocco Forte invited me to a seniors' pro-am event at Sunningdale Golf Club, where I played with the Gary Player's brother-in-law, Bobby Verwey. Bobby guided me around Sunningdale Old Course in 16 over par, mainly by giving me invaluable course management advice. At lunch, I was seated adjacent to Rocco, Jimmy Tarbuck and a nice Australian. As a prelude to proudly telling him of my achievement, I asked the nice Australian how his round had gone that morning and asked him what his handicap was. I was immediately given a kick from the person seated on other side, who whispered that I was talking to Peter Thomson, a five-time winner of The Open Championship, and that professionals do not have a handicap. It was one of those moments where you hope for a hole to open in the floor into which to disappear. I then asked him what he thought had been the principal change to the game over the years. He replied, "The ball". I suppose the distance

that drivers now give the professionals would be a major change, making the second shot into the green a shorter and easier shot.

Colin Frizzell kindly put me forward for membership of the Royal and Ancient Golf Club of St Andrews, with Sean Connery and Eric Sykes as supporters. Willie Whitelaw wanted to help but, as a past captain, he could only informally add his weight. Once I was elected a member, Colin and I regularly attended the Autumn Meeting, during which there was the annual dinner. This was held at the St Andrews Fairmont Hotel, and a series of buses were laid on to ferry us from the clubhouse to the hotel. At the first of these black-tie events, Colin sat down in the bus with an old chum, and an elder golfer came to sit in the vacant seat next to me. It was Peter Thomson who, recalling our previous meeting several years earlier, remarked,

"You seem to have come on in the world of golf."

Another sporting great gave me golf advice at Queen's Club during the Stella Artois tournament shortly after I started to play. I knew that Ivan Lendl was a keen golfer, and I was telling him that I had recently been introduced to the game, and described some of my struggles.

He replied, "No problem, doc, hit the ball good, find it, hit it again."

I'm not sure whether he gave this advice to his daughters, but if he did it worked. Three of his five daughters have gone on to become successful amateur golfers, playing top varsity golf in the US.

I first met Peter Ustinov in July 1988, for *Around the World in 80 Days*, but I continued to see him for other productions, the last time being in October 2000 for *Victoria and Albert*. I always

knew when he had arrived because the chatter and laughter in the waiting room increased. He loved engaging people in discussion and, when cast as Walrus in *Alice in Wonderland*, he tried out his Walrus voice on the assembled waiting room. He had a legendary ability with sounds and could vocally play most of the orchestra.

From the age of four, he was fascinated by cars, and in his 1977 autobiography, *Dear Me*, he describes how, at that age, he switched on his engine as he got out of bed, changed gears on the half landing, and continued 'driving' throughout the day until he reversed into bed at night and switched off the engine. His racing car sounds were wonderful, and he had practised them from an early age. As he once said, "I must have been a real nuisance to my patient mother."

At the end of October 1992, I was called to the set of *The Young Americans* to see Harvey Keitel, who was playing the role of John Harris, an American cop. I was joined at this consultation by the producer Paul Trijbits. Harvey had developed a red eye, making filming difficult. The next day involved three outside shots. The first was early in the morning on Waterloo Bridge, to catch the dawn, the second was on the Isle of Dogs, and the third was late in the evening to catch the dusk on London Bridge. I asked Paul Trijbits if Harvey had done any exterior shots yet and, since he had not, I suggested that he could, like many American cops, wear dark glasses. We ran this past the director, Danny Cannon, who approved, and this subsequently became the defining image of Harvey on the film poster. Paul still recalls this solution, and how it became the face of the film. No time was lost on the filming schedule, and everyone, especially the insurers, was happy.

*

On 17 January 1993, I was reading the *Sunday Express*. This was not my usual newspaper of choice, but I had been tipped off that I was mentioned in the cover story.

I had known John Cleese for some time having, in 1987, seen the cast and director of *A Fish Called Wanda* for their pre-production medicals.

During filming, I began to realise that John Cleese rather liked Jamie Lee Curtis. At the same time, I had started to refer patients to an elegant Texan psychotherapist, Alyce Faye Eichelberger. She had been on her own for a while and had many similarities to Jamie Lee Curtis. John has always been interested in psychotherapy and, in 1983, had co-written *Families and How to Survive Them* with psychotherapist Robin Skynner. The pair had recently written a follow-up, *Life and How to Survive It*. I arranged a dinner in my house in 1987 and invited only two guests: John and Alyce Faye. As John recounted in the *Sunday Express* article in 1993, "I concluded from our first meeting that she had actually grown up in Catford and had developed this accent as a way of making herself sound exotic…"

Her accent was florid Texan, and John's reference to Catford was a typical *Fawlty Towers* throwaway.

"Alyce Faye thought she was coming to Johnny's for dinner with 12 people, and wanted to hit me for her charities. I thought that I had been invited for a tête-à-tête with Johnny, but I then realised that he had prescribed Alyce Faye for me. There is a positive energy in American women, it's not a quality there is a great deal of in Britain today. I am very grateful to him, particularly when he later prescribed a secretary who was extraordinarily good."

Sadly, after several great years together and being very much in love, John and Alyce Faye broke up and had a messy divorce.

Michael Winner, a close friend of John Cleese, advised me to stick to my doctoring, and leave the match-making to others.

In December 1994, Pierce Brosnan was due to play James Bond in *GoldenEye*, but sustained a serious injury to his right little finger at his home in Los Angeles. He came to the UK in January 1995, having had surgery in LA, and I was then involved on behalf of the insurers and the production company to ensure that he came to no harm in the early days of filming. I had him seen by a London specialist, and I requested to see the Walther PPK gun that Bond uses. I was keen to ensure that the weight of the gun on the sutured hand would not press against the repair of his injury and cause a breakdown of the sutures, as this could result in a lengthy period off filming following the re-suturing of the tendon. I made a cardboard cut-out of the gun and put it in Pierce's hand. The base of the handle pressed precisely on the wound. We arranged for a lightweight plastic model of the gun to be created for him to use in the early stages of filming, such as in the interiors of Valentin's lair and office. The dummy gun was also used for Terry O'Neill's stills photography on 24 January. The dummy gun could also be used for the opening sequence after the stills. Having looked at the risk of injury from the weight of the metal Walther PPK, the insurance cover now stipulated that the dummy gun be used as directed. I later learned that the actual Walther PPK was used on one occasion. I suspect that once she heard about this, producer Barbara Broccoli's scream could be heard from the Bond stage at Pinewood Studios to the Eon production offices in Piccadilly. Fortunately, filming was completed without any further issues with Pierce's hand.

A couple of years later, in July 1997, Pierce was again filming as James Bond in *Tomorrow Never Dies* when he was undertaking a fight sequence on the afternoon of 17 July 1997. One afternoon, during a sword-fighting sequence, he sustained a cut to his right upper lip that was deep enough to require suturing. This was done with dissolvable sutures under the skin surface, and a little micropore was applied over the cut. I discussed with the make-up department and the lighting cameraman about applying make-up onto the micropore. Pierce then travelled to Germany and resumed filming 48 hours later. Fortunately, we had minimised the loss of time by carefully avoiding sutures to the skin surface and by applying make-up to the micropore. There was little or no elevation in the skin, and no long-term evidence of the cut.

In May 1995, Sean Bean was filming a scene in *GoldenEye* in which he was head butted. It took 40 or so takes before the director was satisfied with the action. Sean had never experienced back problems, although eight weeks earlier he had had to extend his neck as though he had been shot, and this set up a spasm in the neck. There was a ten-day period ahead that contained no stunt action, but that was followed by a scene in which Sean was knocked off a platform, and then held upside down from a radio antenna. It wasn't exactly Shakespeare, or what you anticipate when graduating from RADA, but the many accidents on set underline what actors go through to produce the exciting action films that we enjoy.

At the start of January 1995, I flew to Rome to see Franco Zeffirelli, who had been in the middle of directing *Jane Eyre* in London, with Charlotte Gainsbourg in the title role and William Hurt as Mr

Rochester. The insurers were trying to determine whether Franco had returned to Rome because he was ill or whether there was a contractual issue with the production company. He had found the production stressful as, like most directors, he bemoaned the film's limited budget and limited shooting schedule. He ranted on about wanting to film the *Jane Eyre* scenes again and use different locations. The new filming was scheduled to begin just after the Christmas break, and Franco wanted the start date to be delayed by two weeks.

He said, "The producer pushes us into shooting on the 9th, without any idea of what we are shooting and where. I have already told him what scene I wanted, then he started to be a writer himself. Foolish. I do not like the rectory in the scene where Jane arrives, and where the uncle leaves her money to become a millionairess. The film needs lots of pick-ups, as it's been done in nine weeks on my skin and now this skin needs a bit of care. I intend to switch off for a week in a retreat, be cared for by nuns, where I take no telephone calls and the nuns put me to bed like a baby."

I duly reported back and left the insurance issues to the loss adjustors. The nuns obviously did the trick and Franco returned to London to complete the film, which was a moderate success.

In late May 1996, I met Luise Rainer, a 74-year-old actress who was due to take part in *The Gambler* having been enticed to return to acting in films after a 50-year gap. She had been won over by producer Károly Makk's persistence and his appealing Labrador-like faithful eyes. I admit that I knew nothing about Luise or her career, but discovered that, in 1936, she had won the Academy Award for Best Actress for her role in *The Great*

Ziegfeld. The following year, she won again in the same category for *The Good Earth*. She was the first and, for many years, only actress under 30 to win back-to-back Academy Awards, although Katharine Hepburn won in 1967 and 1968, but she was over 60 at the time At the time, Luise was on a three-year contract with MGM and she subsequently ended up in poor productions, which left her disillusioned with Hollywood. She returned to Europe, got married, and put her acting career behind her. So, it was a big step for her to take a role in *The Gambler*. When the film was released, she stole every scene she is in, and it was easy to see the magical quality that she brought to the screen. It was not surprising that she had won two Oscars back in the 1930s.

She was, by now, living in Eaton Square near to my practice, and I would often meet her walking around the Square for exercise. She died in December 2014, just 13 days shy of her 105th birthday, forgotten by most but, having known her, and having seen her performance, she is someone I will never forget.

Nor will I forget Richard Harris, who I saw in September 1994 for *Cry, the Beloved Country*. I already knew him from previous medicals, and the occasional personal cry for help. He lived in a suite at the Savoy Hotel, and occasionally my wife and I would dine with him at The Savoy Grill. He was a huge personality, and, by then, had stopped drinking, which had been a problem in his earlier career. He had made a success out of the film and then stage musical *Camelot*. In fact, he owned the rights to the musical, which was a constant source of income for him. He needed that funding, between living in the Savoy Hotel and having the odd mishap, such as leaving his Rolls-Royce in New York in an underground car park for ten years, after which the

parking fees were greater than the value of the car. He sent the keys to the car-park management, telling them they could keep the car!

In early May 1996, Timothy Spall was due taking part in commercials for Nat West Bank. This was being arranged by the Bartle Bogle Hegarty advertising agency. Insurance cover for commercials is slightly different to film insurance, as filming takes place over only a few days, so there is minimal risk of non-appearance during that period. But the concern remains that the cast may become ill while the advertising campaign is being run. If the subject of an advertisement is a food product and the actor becomes sick, public perception of the food product may be damaged. If the advertisement is for a face or hair product, and the actor suffers hair loss or acne, then there is a similar concern. The other consideration is the death and disgrace clause. An actor caught cottaging in a park is not a good advertisement for any product. If they were to be involved in a fraud, a bank's reputation would be put at risk. The disgrace clause is not my area, but the death clause is.

Tim had completed the first of two commercials for the bank without any problems occurring. About six weeks later he was feeling unwell and came to see me, prompted by his wife, Shane.

You may already have noticed that I have not discussed the medical conditions of any of the people I have worked with unless those medical conditions are in the public domain' as is the case with Tim. I have obviously gone into detail about stage and film set mishaps, which are situations that do not ordinarily occur in everyday life.

One or two signs gave me cause for concern during examination of Tim. I extracted, what Tim describes as a gallon of blood, from his arm and had the bloods immediately couriered to the laboratory. I asked Tim for his telephone number and asked him to keep his telephone on until he heard from me. Within an hour, I knew that he had an advanced stage leukaemia. I phoned him and told him that I had arranged for him to be seen by a haematologist immediately. His first reaction was that of the consummate professional: "I cannot go into hospital," he said. "I have to fulfil my obligation to the fly to Cannes tomorrow as part of the promotion for *Secrets and Lies*"

(This Mike Leigh film went on to win the Palme d'or for best film and Brenda Blethyn won best actress)." After explaining my concerns, he went into hospital, and I am glad to say that he made a complete recovery and continues to work consummately and give pleasure to his many fans.

The day after he was admitted to hospital, I received a telephone call from one of Tim's *Auf Wiedersehen Pet* co-stars, Jimmy Nail.

"Dr John, Tim is my mate and I want to know if there is anything that he needs, and I will make sure that he gets it. And I mean anything."

Jimmy rang from time to time to make sure that Tim needed nothing other than friendship.

Tim has been involved in many well-received projects. With the director Mike Leigh, *Secrets and Lies*, plus *Topsy-Turvy* and *Mr Turner*, and he won awards for all three films. He learned to paint for his title role in *Mr Turner*, holding his paint brush as Turner did, as though he was painting a wall. He then played L S Lowry, and painted in a more conventional manner, holding the brush

with his fingers. Since those roles, Tim has taken up painting for his own pleasure, while endless scripts continue to drop onto his door mat.

I remember asking him if he still received a lot of scripts. He replied, "Many come through the letterbox, John, but nowadays they are mostly for my son, Rafe."

This was not true, of course, but is a sign of a family man for whom I have the utmost respect.

Frank Bruno, the heavyweight boxer, had to fill in a form related to insurance cover for his next fight. Under the section that asked about any other activities, he replied, "Ducking and diving," which related to his pantomime performances, I suppose!

In early August 1997, I visited a lovely house overlooking Richmond Green. It was the home of Lord Richard Attenborough, the actor and film director. I had seen him in the past and, on one occasion, he had written to me on the headed notepaper of his film company, Beaver Films. I then contacted him because the wood-engraved image of the beaver looked as though it might have been made by my uncle, Reynolds Stone. He confirmed that this was correct, and sent me a headed compliments slip, which featured a different Reynolds Stone image. It was always a pleasure to see Dickie, usually at his elegant home. The last time I saw him was in 2006 for his medical for *Closing the Ring*.

When an actor dies during a production, the potential costs can be huge. *Gladiator* had a budget of around $103 million and, in July 1999, one of its actors, Oliver Reed, died suddenly, apparently from a heart attack. I had done the pre-production

cast insurance medical seven months earlier and Oliver had not declared any cardio-vascular problems. Indeed, I had seen him on many occasions in the past and he had never mentioned heart problems. The insurers were anxious to establish whether there had been non-disclosure, but his own doctor confirmed that he had no record of heart problems. The resulting claim would have to be covered by the insurers. Oliver had not completed his role in the film, and there was no question of recasting him, as it would involve getting another actor to film all the completed sequences again. The post-production company, The Mill, which specialises in computer-generated imagery effects, created a digital body double for the remaining scenes involving his character, Proximo. They photographed a live-action body double in the shadows, and then mapped on to that a three-dimensional computer-generated image mask of Oliver Reed's face. The remaining scenes were completed at a cost of around $3 million for those two minutes of screen time!

12

A bright new century

At the end of June 2000, Jason Flemyng came in for a cast insurance medical for *From Hell*. I had seen Jason on many occasions and we always ended up chatting. I admired him for having helped to finance *Lock Stock and Two Smoking Barrels* when some extra money was needed to complete the film. Not many actors have done that, and hats off to him, because it was a great success, and hopefully he was rewarded for his financial bravery. When he came to see me, he had just completed filming *Snatch*, also directed by Guy Ritchie. One of the co-stars was his good friend, Vinnie Jones. Near one of the film locations, Jason had passed a jeweller's shop that had top of the range watches in the window, including a Rolex that he lusted after. Near the end of filming, he was having a few drinks with Vinnie, and noticed

that Vinnie was wearing the Rolex.

"Where did you get that watch, mate?" he asked.

"Did some work for Rolex," Vinnie replied. "They paid me and also gave me this watch."

"I've been looking at that model in the shop near the shoot, went in and asked the price, but it was too much."

"You effing have mine," said Vinnie, as he took off the watch and gave it to Jason.

"No way, mate, you've had a few jars, as have I. Ring me in the morning and come and collect it from my hotel room."

The next morning, Vinnie called Jason, who immediately said, "Morning, have it back now?"

To which Vinnie replied, "No need for that, but what's the f****ing time?"

In August 2000, an 11-year-old boy came to see me with his father, Alan Radcliffe, who had to sign the forms for his son, as he was underage. The boy was Daniel Radcliffe, who had been cast in the lead role in *Harry Potter and the Philosopher's Stone*. Alan Radcliffe is a literary agent, and Daniel's mother is a casting director. To have family who understood the ins and outs of showbusiness must have been a great support to the child actor, who was about to undertake a role that would throw him into the spotlight unlike any other contemporary child actor, with the exception of his co-stars, Rupert Grint and Emma Watson.

Daniel happened to be at Sussex House in Cadogan Square, the same school as my son Thomas, and the pupils were given a preview of the film before it went on general release, much to the joy of Daniel's school friends.

*

In September 2001, I drove to Leavesden Studios to see the director Christopher Columbus for *Harry Potter 2*. Often, at the pre-production stage, the final name for the film is not used. *Harry Potter 2* would become *Harry Potter and the Chamber of Secrets*, again produced by Warner Bros. On my arrival, I was shown into a room where several other people were already sitting around. On closer inspection, they were all actors. It transpired that Christopher was in the middle of a casting session, and when a gap appeared, he was going to squeeze me in for the medical. As I sat there, a familiar face walked in and sat next to me. It was the actress Juliet Stevenson. She turned to me, and asked,

"What part are you here for, Dr Gayner?"

"Actually, I am doing Christopher's routine medical for the film."

"Oh, I'm so nervous," she said.

"But Juliet," I reassured her. "You are such a great actress, and must have done this many times before. Are you always this anxious?"

"No, but so many of the films or TV shows that I act in are unsuitable for my children to watch, so they are desperate for me to be in Harry Potter."

Sadly, I do not think she got the part, but there was some consolation, as she was the voice of Emily Cratchit in the animated version of *A Christmas Carol*, which was being made at around the same time.

In October 2001, I had two cases of well-known American actresses who were unable to perform due to severe abdominal bloating and constipation, with consequences for the production companies.

The first was an actress who had visited a curious dietitian in Hollywood who had put her on a diet of popcorn, and little else, to help her lose weight. She had, as a result, become severely constipated and unable to work. I was asked to see her in her hotel and, once I reached her corridor, I could detect the distinctive smell of popcorn. Upon entering her room, the smell became more intense, and there was a popcorn-making machine hard at work on the table. When I examined her, she was clearly so constipated that she needed hospitalisation and inpatient care. I arranged for her admission and made it clear that she would have to abandon the popcorn and revert to a more traditional diet.

The second case presented a more common problem. Three weeks before arriving in London for the starring role in a film, this actress had fallen and broken her right arm in three places adjacent to the elbow. She had been treated in a sling and been given strong painkillers. She complained that, on the flight from LA to Heathrow, the arm was very painful and she needed more of the painkillers she had been prescribed in Hollywood.

Three days later came her cry of desperation, "The hotel chambermaids have thrown all my medication away and I need a prescription to replace my lost painkillers."

The chambermaids had done no such thing, and now she was doubling up on medication that, among other things, caused constipation. She had also stopped eating useful things, such as cereals and fruit, and she was in trouble. I had serious doubts about her ability to perform without delays to production. I wrote to the insurers:

"In view of her general condition and state of mind, I cannot recommend an uncertain wait for her return to the production. Taking into consideration the time restraints imposed by the

schedule and her stop date, I believe it is in her best interests to return to America to continue her convalescence under the care of her own doctors, and for the production to recast her."

Having recently suffered a fracture, she should never have been cast in the first place but, no doubt, her agent had reassured them that she would be fine, particularly as there was very little physical action in the film.

At the end of June 2001, I was having lunch at what is now the Colbert Restaurant, in Sloane Square, adjacent to my practice, when I received a call from Robert Fox, producer of the Viacom film *The Hours*.

Filming was taking place in a diving tank in north London, and one of the actresses was worried about herself having been in the tank. She wanted to discuss the situation with me, and Robert asked if he could put her on the phone to me. I agreed, and spent the next several minutes discussing Nicole Kidman's anxieties with her. I later received a follow-up call from the producer saying that Nicole was insisting on being seen and examined by me before she went back in the tank. I reluctantly agreed to cancel my afternoon's consultations, and travelled over an hour up to the location. I was met by Robert Fox, who told me that the actress was now in the tank and no longer wanted to see me. I suggested that it would be sensible if I were to examine her, since I had travelled all this way to see her and it would reassure everyone that she had come to no harm. No, I was reassured, she did not wish to see me, so I agreed a commensurate fee with the production company for my waste of time and my cancelled afternoon consultations, and I drove back to SW1. I was annoyed because two patients on my cancelled afternoon list were anxiously waiting recent cancer test

results, and they would have to wait another agonising 24 hours for their results.

Later in the day, as I drove back down Park Lane, I received an urgent call.

"Can you please visit Chris Evans at his house in Belgravia?"

"Of course, what is the problem?" I asked.

"He is in the middle of an extremely stressful situation with Scottish Media Group, owners of Virgin. They are sacking him from his breakfast show, and he has asked to see you."

I arrived at the house and was greeted by Billie Piper, his wife at the time. She took me downstairs to the kitchen and made me a cup of tea. Chris was upstairs talking to his solicitor and, after about 20 minutes he appeared, and we went off to have a discussion. What I am about to describe has since become public, and been reported by BBC News, since I ended up in the High Court to relate the findings of that visit.

I told the court that Chris was a "real mess" the day before he was fired by Virgin Radio. He was "chronically stressed" and kept crying. Not only had he lost his job, but there were conflicts over £8.6 million worth of share options, which he believed that he was owed. During my visit, he constantly repeated the phrase, "Don't get rid of me because I've done nothing wrong".

I told the court, "My diagnosis at the end of the meeting was that he had become chronically stressed resulting in an acute anxiety state which he clearly manifested at my examination on 27 June."

I also stated that, "I am in no doubt that if Mr Evans did not take a break from the pressure of work then his mental state would worsen."

This was supported by the findings of a psychiatrist who added that Chris did not suffer from a psychiatric disorder.

Chris had not turned up for work for five days due to a conflict with Virgin Radio and this had resulted in his acute stress. In spite of all the medical evidence, he lost his case against Virgin Radio for unfair dismissal and had to pay £1 million in costs.

So, 27 June proved to be an eventful day with interesting, and different, approaches to the doctor from high-profile media people. I leave you to guess my feelings about each performance.

One of the largest files in my practice belongs to Sir Michael Caine, who I first saw for *The Holcroft Covenant* in July 1984. Since that first visit, there have been many pre-production medicals and, in December 2001, he was due to appear in *The Actors*. I have seen him most recently in June 2018, for *Four Kids and It*.

Otherwise, Nicky and I bump into Michael and his wife, Shakira, at the Colbert Restaurant from time to time. In all the time I have known him, he has not been responsible for a single stoppage, and he has never been late for his appointments with me. He is the consummate professional, and has given us hours of film time to enjoy.

In February 2002, Tim Pigott-Smith invited Nicky and I to a Royal Shakespeare Production of *Julius Caesar*, in which he played Cassius. The production had moved from Stratford to the Barbican Theatre, and we were invited to the show in the early stages of the run. Nearing the end of the performance, there was a hitch, and a piece of scenery became stuck mid-stage. The

audience was asked to wait for 20 minutes while the crew tried to rectify the problem. When we returned to our seats, a member of the production team came through the gap in the curtain and told us that the stage could not be rectified, and that it had been decided to halt the production. We would be given a full refund or the option to rebook for another night. A wag in the audience shouted out, "Perhaps you could tell us what happens next."

We went to see Tim afterwards, and he was not best pleased, as there had previously been other stage problems, and the other actors were looking to him to be their voice with the production management.

In September 2004, I travelled to see Keira Knightley, who I had previously examined for many film parts. This time, she was at Basildon Park, near Pangbourne, filming *Pride and Prejudice*. It was late morning, and a short lunch break had been called. I had to carry out an essential element examination, which included an electrocardiogram. This meant applying adhesive pads and leads across her chest. This is normally a straightforward procedure, but Keira had been sewn into her tight dress with the seam at the back, and there was no time to cut this open and sew it up. I was in the difficult position of having to fumble around to try to apply the six ECG pads in the correct positions, without causing embarrassment to either of us. As luck would have it, Keira's mother was in the Winnebago that day, and I was extremely grateful for her presence to ensure fair play all around.

Uri Geller came to the practice in March 2009, and I have a signed and bent teaspoon in my bookcase as a reminder of his visit. This was his signature piece in his TV appearances, and

I was certainly impressed when he managed to stroke the spoon into a bend right in front of me. He made a quick turn with the spoon, out of my direct line of vision, and I suspect this was his opportunity for a heave on the spoon.

13

Film career mishaps

On my trip to Ireland for the ill-fated *Divine Rapture*, I had to give Johnny Depp a routine medical. In March 2004, I visited the set of *The Libertine* to see him again. On this occasion, he noticed my italic handwriting and pen, and this started a conversation that included the fact that Alec Guinness, who Johnny admired, also had italic handwriting, and had asked after the pen. Johnny was keen to catch up when back in London and took my mobile number. Three weeks later, my wife told me that our housekeeper had taken a call from a Mr John Depp, and when asked if she had taken his number so we could ring him back, the reply was, "No". Mrs Gayner was very disappointed indeed!

In November 2013, I travelled to Hampstead to see Johnny Depp who was now filming *Mortdecai*. We chatted about the fact

that I had met his new wife, Amber Heard, before she had met him, albeit in a professional capacity.

I have been saddened by the recent High Court proceedings, and the field day the press has had over the lurid details of their private life. They have appeared on the front page of *The Times* and on the BBC *News at Ten* all too regularly. Johnny is a talented actor, as well as one of the highest grossing actors in Hollywood. However, following claims of alleged assault and the outcome of a claim against News Group Newspapers, Johnny was asked to step down from his role as Gellert Grindelwald in the third *Fantastic Beasts* film. At the time of writing he is reported to be considering an appeal against the High Court decision but, for now, his film career seems to be on hold.

Other careers have been disrupted due to events outside of the business. Michael Barrymore comes to mind. I first met Michael in September 1986, when I drove up to Great Yarmouth, where he was performing Monday to Friday. At weekends, he then travelled to Scarborough to perform the same show. He was at the height of his fame, with TV shows that attracted millions of viewers, including *Strike it Lucky*, *My Kind of People*, *My Kind of Music* and *Kids Say the Funniest Things*. In fact, I had just done a medical for a new series of *Kids Say the Funniest Things* when a 31-year-old man, Stuart Lubbock, drowned in Michael's swimming pool, and the series was never filmed.

In 2011, Michael took part in a celebrity version of *Coach Trip*, having not had much work other than his 2006 participation in *Celebrity Big Brother*. In *Coach Trip*, which was being filmed in Ajaccio in Corsica, he took part in a horse-riding activity on a

sandy beach. He had been given some horse-riding instruction and a helmet. Unfortunately, he fell as he was mounting a horse that Ajaccio Equitation had advised was appropriate for his ability, height and weight. He landed on his head, cracked a tooth and bruised his hip. He suffered the consequences of this injury for several days and, once again, horses were the cause of film set trauma.

In March 2019, Michael was preparing to take part in *Piers Morgan's Life Stories*. I met Piers before filming, and mentioned that I hoped the show would be kind to Michael, who had suffered terribly since the swimming pool catastrophe. I had gotten to know Michael well, and felt that he had suffered from a trial by the press that had ruined his career.

I first met Kevin Spacey in June 2005 when he was cast in the Bryan Singer directed *Superman Returns*, and I continued to see him in his role as artistic director of the Old Vic Theatre. One of my duties was to give him a certificate that allowed him to travel across the Atlantic with his little dog, who was an important part of his life. During his time in London, Kevin had two or three assistants, and each one said that they did not want to be in the post if the little dog died on their watch. Kevin must have told some of his showbiz friends about how he managed to travel with the dog between London and Hollywood, since a number of other notable names began to beat a path to my door for assistance with their favourite pooch.

I knew Kevin enjoyed the company of tall blond men, and he publicly come out as gay in October 2017. On one occasion, he was in the practice and looking at photographs in my bookcase. He asked about the good-looking tall blond boy, around 18 years

old. I told him that it was my youngest son, Charlie. Later in the afternoon, my secretary, Hilary, received a telephone call from Kevin's assistant, with an invitation for Dr Gayner and his 'son' to join him on the following Tuesday evening at an unveiling of his portrait at the National Portrait Gallery. When I heard this, my first thought was to refuse. However, on second thoughts, I rang up my eldest son, Justin, who had been a journalist and now worked on John Lloyd's *QI* television show, and had met Kevin sometime in the past. I asked Justin if he would be the 'son' for this outing, and he agreed, but added that there would have to be a little 'gotcha' nudge on the evening. Kevin was on good form, and the 'gotcha' went down well. Fortunately, our relationship was such that he accepted the approach I had taken, probably because he appreciated my assistance with his little dog.

In October 2017, actor Anthony Rapp accused Kevin of making sexual advances toward him in 1986, when Rapp was 14. Following this, other man came forward alleging that Kevin had made unwanted advances and had sexually harassed them. As a result of the allegations, Netflix cut their ties with him and removed him from the final episode of *House of Cards*. His role as J Paul Getty in Ridley Scott's *All the Money in the World* was reshot with Christopher Plummer taking over Kevin's part. All the cases against Kevin have been closed but, just like Michael Barrymore, his career has come to a halt.

During his time as artistic director at the Old Vic, Kevin was photographed sitting with Ghislaine Maxwell in the Throne Room at Buckingham Palace, during a private tour. Prior to Robert Maxwell's death in 1991, I had seen his daughter Ghislaine

from time to time. I understand that I may be a name in Jeffrey Epstein's little black book of contacts, which may explain why, in early 2020, I was contacted by the press, enquiring if I knew the whereabouts of Ghislaine.

She must have told Jeffrey Epstein that he should contact me if he needed a doctor while he was visiting London.

Ghislaine and I never discussed her father or any other members of her family. But I do recall hearing from a journalist, who worked at the *Daily Mirror*, that when Robert Maxwell landed on the roof of the building in his helicopter, the staff would say to each other "The ego has landed," a take on the 1976 British war film *The Eagle has Landed*.

In November 2017, I visited Edward Westwick at his parent's home in Stevenage. Here was another actor whose career was temporarily on hold due to external events. He was appearing in the BBC Two comedy series *White Gold*. Edward is probably better known for his role as Chuck Bess in *Gossip Girl*. He had not turned up for work in the preceding 24 hours, which caused an issue between an insurance claim for ill-health and a contractual problem with the producers. Just before my visit, three American women had made claims of sexual assault and rape against him. He was on the phone to his agent and lawyers in Hollywood when I arrived at the house, and the conversations continued for some time. I chatted to his mother and gained a useful insight into Edward's normal, happy family life. It seemed clear that the accusations were likely to be groundless and, indeed, they were subsequently dropped. But the #MeToo movement was, by now, well established, and the producers immediately halted production of the second series of *White Gold*.

191

Edward had just completed a BBC adaptation of Agatha Christie's *Ordeal by Innocence*, and his scenes were re-shot using another actor.

Here was another example of a career brought to a standstill by accusations that were subsequently dropped. However, it seems that Edward has been able to move forward, having filmed *Enemy Lines* in 2020, and his role as Tyler Jones in *Me, You, Madness* is, as I write, now in post-production.

14

Back on a film set

In the summer of 2007, some of the production team from the stage production of Michael Morpurgo's *War Horse* went to the Hyde Park Barracks of the Household Cavalry Mounted regiment. They wanted to look in detail at the movements of the cavalry horses. The stage horses were to be life-sized puppets made by Handspring Puppet Company and operated by dancers and puppeteers. These puppet horses were one of the enchanting features of the play that premiered at the Olivier Theatre on 17 October 2007.

The production team invited members of the Household Cavalry to the opening night. In the green room after the show, the officers said that the puppet horses were so lifelike that they would be interested to see how one of their horses would react to

the puppet horses. It was arranged for a cavalry horse to go to the stage entrance one afternoon and be taken in the large lift up to the Olivier stage. This horse was the leader of the cavalry pack and its job was to look down the line of horses in a parade and, if the neighbouring horse was out of line, bump it back into line. The horse was led onto the empty stage and the puppet horses were brought onto the stage one by one to form a line alongside him. He was not at all put out by them and, after the line was complete, he looked down the line and bumped the adjacent puppet horse, which was clearly not in a military straight line. What a compliment to Handspring Puppet Company and the puppeteers.

I first met Robert Hardy when he was injured in the incident involving the carriage that had turned over when the horses panicked after their driver fell through the rotten wooden board on which he was standing. Fortunately, Robert suffered only minor injuries in that accident. In July 2008, he came to see me prior to filming *Margaret*, a film about Lady Thatcher. He was cast to play Lord Whitelaw, and he was interested to hear about Willie from my perspective. Clearly, he felt this first-hand experience would help him fill out his characterisation of Willie.

I had a similar experience in 2001, when I saw Dame Penelope Wilton in the film *Iris*, based on the life of Iris Murdoch. Judi Dench and Jim Broadbent played the older Iris and her husband John Bayley, while Kate Winslet and Hugh Bonneville played the couple in their younger years. Jim Broadbent won an Academy Award for Best Actor in a Supporting Role.

Penelope played the role of Iris Murdoch's and John Bayley's great friend, Janet Stone. Janet was married to my mother's

brother, the artist, printer, and wood-engraver Reynolds Stone. Again, this was a felicitous happenstance, as I was able to share my experiences of staying with Reynolds and Janet at the Old Rectory in Dorset. Janet was friends with a coterie of the creative world, including Benjamin Britten, Peter Pears, Lord Kenneth Clark and John Piper.

Several years before I had seen Peter Pears regarding insurance cover for a film of the Benjamin Britten opera *Death in Venice*. Unfortunately, I was unable to pass Peter for insurance cover, due to his high blood pressure and, sadly, a week later, he had a stroke. The film was to record his singing and performance as Aschenbach, which he had sung at Aldeburgh in the 1970s. Unfortunately, the film, which would have recorded his performance for posterity, was never made.

In November 2009, John Landis was about to direct *Burke and Hare*, about Scotland's infamous grave robbers, who resorted to murdering unfortunates they picked up in pubs when they had run out of fresh graves to plunder. The bodies were then sold for dissection. John was famous for such wonderful films as *The Blues Brothers* and *Trading Places*. I had seen John before, and while we were chatting, he asked if I would be happy to spend a day or two appearing in the film. I agreed, and the first thing to be done was have a costume fitting for my role as an Edinburgh physician. Filming was fun and took place at Osterley Park in south-west London. The other 'Edinburgh physician' adjacent to me in the scene was the co-producer of the Bond films, Michael Wilson.

Osterley Park, ancestral home of the Earls of Jersey, was given to the National Trust in 1949. The oldest of my patients lived in

Eaton Square and in her drawing room she had a photograph of herself on the steps of Osterley Park, aged 20 and having married Lord Jersey. She was extraordinarily beautiful and had come to England from Australia to do the 'season' as a debutante. I'm told that when she walked into a large dance, people would stand on chairs to catch a glimpse of her. She had several husbands and lived to the ripe old age of 101. Her stories of boating in the Mediterranean in the 1950s with Viscount Camrose and visiting the Rothschilds in Paris were a glimpse into another and bygone world. Although she found more recent events hard to recall, her memory for those outings remained. Sadly, this seems to happens to all of us as we get older!

Lord Lucan's disappearance in 1974 has remained an unsolved mystery and, by now, nearly all of his gambling contemporaries from the Clermont Club are no longer with us. Numerous theories have persisted about his disappearance and, for a while, there were rumours of sightings all over the world. At the time, I remember talking to Charles Benson, the 'Scout' at the *Express*, and he felt that 'Lucky' Lucan had taken a cross channel ferry and jumped from it. Another friend, Susie Maxwell-Scott, came up with the theory that John Aspinall, the owner of Howlett's Zoo, had taken Lucan to France in his private boat and then driven him by car to a cottage he owned in Switzerland. Then, she said that Lucan had wanted to return to London to see his children and clear his name. Aspinall feared that this would expose his part in Lucan's disappearance, so arranged for him to be taken across the channel, shot and thrown overboard. This latter theory formed the basis for a two-part TV series which was broadcast in December 2013.

John Aspinall had lived at 1, Lyall Street in Belgravia and filming was taking place in the house in the summer of 2013. In late July, my secretary interrupted a morning consultation to tell me that I was urgently needed at the location, as Christopher Eccleston, who was playing John Aspinall, had been bitten by a tiger. I packed my medical bag with sutures, dressings and a tetanus injection, and off I went.

I knew that two of Aspinall's zookeepers had been killed by a tiger in 1980, and the head keeper at Howlett's Zoo was killed by a Siberian tiger in 1994. Aspinall's friend, Robin Birley, had been mauled by another of Aspinall's tigers when he was 11 years old. As a result, he had had many operations on his face, but was left permanently disfigured. Bearing this in mind, I drove rather anxiously at speed from the practice to 1, Lyall Street.

I parked my car in a convenient space in front of the house, with all other places taken up by production trucks. As I got out of my car, one of the production team came up to me.

"I am sorry, but you can't park here, gov. They are filming in the house and the street is in shot."

"Actually, I am a doctor," I replied. "And the production put out an urgent call because someone has been bitten by a tiger."

"Okay, doc. I'll mind the car for you."

I gathered my medical things together, walked towards the house and, as I reached the top step and was about to enter the house, the same production chap shouted out, "Doc, the tiger's still at large."

There was no large tiger at large, rather a baby tiger that was, by now, back in its cage. In the scene, Christopher Eccleston had been sitting on a sofa stroking the baby tiger, which was something that John Aspinall was fond of doing, when it gave

him a tiny nip on the hand. There were minor puncture wounds, but no bleeding by the time I arrived. There was no need for sutures or bandages, just a tetanus shot and reassurance all round. But an actor bitten by a tiger in Belgravia was a new one for my list of film-set accidents, particularly on my home turf!

The supermodel Cara Delevingne was due to appear in a production called *Paper Towns* and she came to the practice pre-production. I have known her parents for some time, and we were able to catch up on how everyone was fairing, while sorting out the medical. When I opened the door of my consulting room to see her out, we were greeted by Daniel Radcliffe with his minder. I introduced Cara to Daniel and let them chatter for a while, at the end of which Cara mentioned that she had come on her bicycle with paparazzi in hot pursuit, and she was sure they would be waiting for her downstairs. Daniel turned to his minder and asked him to accompany Cara out, and to prevent the paparazzi from following her as she left. Daniel and I did the necessary for his upcoming project, and I let him out into the waiting room where I found his man with a rolled-up trouser leg, a large bleeding gash on the lower leg, and his shirt dirty and torn. He explained that one paparazzo on a motorbike had run him down while trying to follow and photograph Cara. I patched him up, and the experience underlined the horror of being a celeb who could be followed and photographed at any time, and the ruthlessness of the paparazzi who will stop at nothing to get their photograph.

I first met Dame Maggie Smith in 1985 for the film *A Room with a View*, based on the E M Forster book of the same name, directed by James Ivory and produced by Ismail Merchant. The

film was a success, winning three Academy Awards and five Baftas, including Best Leading Actress for Dame Maggie. This helped to increase the profile of Merchant Ivory films and it was followed by *Howards End* and *The Remains of the Day*. Merchant Ivory had already made *Heat and Dust* in 1983, starring Julie Christie and Greta Scacchi, which had been well received. They were involved in numerous other productions, and there was always a slight anxiety that funds would run out before the project was completed. But the cast and crew always had the pleasure of eating Ismail Merchant's wonderful curry dishes, which kept them contented and on track.

In October 1994, Dame Maggie Smith played an autocratic 92-year-old in Edward Albee's play *Three Tall Women*. The play opened at The Wyndham's Theatre, with Frances de la Tour and Anastasia Hille also in the cast. Nicky and I went to see the play, and afterwards went around to see Dame Maggie in her dressing room. She was seated opposite a mirror, removing her extensive make-up, when Twiggy and her husband Leigh Lawson, came in. There were greetings all around, before Leigh spoke up.

"Maggie, I am surprised not to see Paul Scofield here, as I saw him in the dress circle during the play."

Still removing her make-up, Maggie replied, "Oh, he's far too busy catching trains back to Sussex. In fact, he is so busy catching trains back to Sussex that he almost misses the last act of his own plays."

Paul, being shy and liking to keep himself to himself, would have preferred to drop Maggie a postcard afterwards to say how much he had appreciated her performance. Which, needless to say, was peerless.

More recently, Maggie played the role of Violet, Dowager

Countess of Grantham in *Downton Abbey*. Prior to starting work on the film of *Downton*, Maggie came for her pre-production medical. When I asked if she was looking forward to reprising her successful role, in which Julian Fellowes gives her all the best throw-away lines, she replied, rather disparagingly, that she thought she was done with *Downton*.

During a coffee break while filming one morning, an assistant asked Maggie, "Is there anything you would like, Dame Maggie?"

"Yes," she replied, "A death scene."

In March 2011, I was asked to meet Alfonso Cuarón, the director of *Gravity* and the film's star, Sandra Bullock, to discuss certain aspects of the film that they were just about to start shooting. This space fiction film was to be filmed in London, with the computer-generated images to be created at Pinewood and Shepperton Studios. I was consulted about how Sandra Bullock's character would look under the various conditions that she would face in this space mission gone awry. I discussed this in detail, going over the blue lip (cyanosis) appearance of oxygen depletion. We talked about sweating and being pale, and what would happen to sweat and tears in a negative gravity environment. Sandra had brought her assistant along, who took copious notes as we discussed aspects of the film. I was telephoned again for further medical input and I was given a credit at the end of the film. Knowing this, I insisted to Nicky that we sit through the main credits until they reached my moment of movie recognition. By then, the rest of the audience was already out on the street hailing taxis. If the credit mention had been translated into a slice of the profits, I would not have complained, as the film grossed over $730 million.

15

The longest house call in history

In the early 1970s, shortly after starting practice, Lionel Walker-Munro, otherwise known as Pip, came to see me. We became good friends, and he lived in a lovely house at 22, Little Chester Street. He had a twin brother, Hugh, known as Squeak, so, together, they were Pip and Squeak. Originally, they were known as Damn and Blast because their mother wanted a girl. Pip had a successful career at Eton and Oxford. In those days, it was quite important to go to the right college, such as Magdalen or Trinity, but Pip went up to Wadham. When he was asked which college he was at, he would always say he was at Wadham O, and this was because his friends were so surprised that they would respond with "Wadham – Oh!"

He came from a wealthy family, with an estate in Drumfork in Scotland, where they gave frequent dinner parties and dances.

They also had another estate in Hampshire.

Pip had been in the Intelligence Corps, which I only discovered when talking to one of his friends. He then joined the merchant banking firm, Morgan, Grenfell & Co. However, when he was 28, and on holiday in Italy, he was driving an open top Jaguar when he was involved in a terrible accident. He was unconscious for four weeks, sustained brain damage, and did permanent damage to his left eye.

The accident imbued him with an irrational fear of his life being dictated to by an outside force that he named 'The Mogul'. This was so powerful that he sold up 22, Little Chester Street and moved to New Zealand. I wrote to him regularly, and had lovely replies, but moving to New Zealand clearly had not released him from the terrorising influence of 'The Mogul'. The family solicitors were becoming increasingly worried about him and the consequences of his harming himself. This would have led to heavy death duties on the family assets he had inherited, as no estate planning had taken place. It was decided that I should do a house call from Cadogan Place, London SW1 to Hamilton, New Zealand. I have not registered this as the longest house call with the *Guinness Book of Records*, but I wonder if one longer has been recorded.

I flew out to New Zealand and contacted Pip to say that I was on a trip to the area, and was hoping to meet up with him. We arranged to do some fishing on Lake Taupo and then experience the volcanic sulphuric smells of Rotorua. We talked a lot during the visit, and I persuaded him to return to London and that I would help his battle with 'The Mogul'.

After my visit, I managed to get Pip back to London, where he eventually moved to a flat above my practice at 6 Sloane

Square, where my secretary, Hilary, and I were able to keep a close eye on him. I managed to quell 'The Mogul' with appropriate medication and Pip led a contented and much happier life, albeit limited as a result of the accident. He took to sitting downstairs in the hall of 6 Sloane Square, where he could watch the world go by, and he managed to charm a whole generation of workers and residents in the Sloane Square area. He was always immaculately dressed in a Savile Row suit and was never without a tie. He would open the door for people with luggage or parcels, and was known to hail taxis for women with packages, helping them and paying their fares. He had the politeness and manners of a bygone era, a rarity in today's world. It was a sad day when he died.

In June 2013, actor Julian Sands visited me and put a silver tumbler on my desk, saying that he might be able to acquire it for me from a friend of his. He knew that I had a long-standing interest in theatrical memorabilia and paintings, and that I was a member of the Garrick Club. The Garrick Club, which had many actors as members, was formed in the 1830s, and had accumulated a world-famous collection of theatrical portraits and ephemera. Julian thought that either I or the Garrick Club might buy it.

On the side of the tumbler was engraved: "The friend thou hast and their adoption tried, grapple them to thy soul with hooks of steel" and underneath "D.G. to J.M. Theatre Royal, Drury Lane 1774".

J.M. turned out to be John Moody, an Irish actor, who played in at least nine plays at Drury Lane in 1774 for his actor manager, David Garrick. The principal plays were *The Fair Quaker*, *The Register Office*, *The Committee* and *The Note of Hand*, for which Moody spoke the epilogue.

The quote on the silver tumbler came from *Hamlet*, act 1, scene 2, when Polonius speaks to Laertes and ends:

"But do not dull thy palm with entertainment of each new-hatch'd, unfledged comrade."

On the underside of the tumbler was the silver mark of James Young and Orlando Jackson. There is a silver tea service at the Victoria & Albert Museum with this silver mark, dated 1774. Garrick had paid £140 to the same maker for a large silver order for his house in the Adelphi, and the tumbler was almost certainly added to that order. This confirmed the provenance, and gave me the certainty that the tumbler had been commissioned by David Garrick himself.

Through Julian, I was able to arrange for the Garrick Club to acquire this unique piece of silverware to add to their extensive collection of theatrical paintings, books and ephemera.

Epilogue

My last paid employment before stepping back from my medical career was in December 2019 when I was involved in a day's filming on the production *Twist*, in which Rita Ora played a policeperson on location at the Charterhouse Buildings in the City of London. The production was nearing the end of principal photography and they had booked the location for only one day. Rita was poorly, but anxious to complete her role in the film without causing any delays, which would have caused serious problems due to the location and her other commitments. We managed to get through the day's filming and, as a true professional, she got through her part even though she felt distinctly below par. We had the occasional large laugh, and I have photographic evidence of this.

While we were being photographed for fun, I asked her what was the word?

"Cheese," she replied.

"No," I said. "The word is 'testicles'", and the photographs record her response.

I hung up my stethoscope at the end of 2019 and have since embarked on new adventures.

I have been fortunate to have had the privilege to meet and look after many talented and motivated people from different backgrounds during the course of my career. As my career progressed, I have never lost my interest in all my patients, their families, careers, and importantly, where appropriate, the family pet. I have learned a huge amount from listening to my patients, and I have benefited from this. At the same time, hopefully my patients appreciated someone listening to them in a supportive way. I am missing this interaction, although my computer inbox and phone are still a point of contact that is being used by many long-term patients for a view on something that is worrying them.

"Are you enjoying your retirement?" I am now often asked.

To which I reply, "Retirement is not an option, but change of focus is."

In his book, *Aging Well*, George E Vaillant writes about a Harvard University study of adult development. It is clear from this study that ongoing involvement with the younger generations, and their creativity, is a key and helpful part of this process, which he refers to as "passing on the mantra". Interaction with friends, the study suggests, is also a key part of the support

system. Sadly, this was curtailed for many of my patients during the COVID-19 pandemic. So, I have continued to call and talk to many of my long-term patients who find themselves in this situation. At the same time, I have been involved in setting up the National Bereavement Partnership, which has given me the opportunity to contact some of my actor patients and friends who have performed a version of Carole King's 'You've Got a Friend'. This has helped to promote the charity, which is now fully functional and doing excellent work with those affected by the pandemic.

I am very involved as a trustee of Wilton's Music Hall, which has been affected by the 2020/1 Covid19 pandemic in having to close its doors to live performances.

Wilton's is on Graces Alley, off Cable Street in Tower Hamlets. It is a Grade 2* listed building and is possibly the oldest surviving music hall, retaining many original features. Having been involved with the restoration project, I take great pleasure in seeing the hall being put to its proper use as a performing arts venue.

Fortunately we have been able to have some income from renting our original Victorian interior to film and TV companies. We have also been helped to survive by the government Covid grant to the arts.

My life has been blessed by having a career that suited me and that gave me an insight into many different and fascinating walks of life. My life has also been blessed by having a wonderful family. Nicky and I have been together now for over 30 years, and I have four sons and two grandchildren. Perhaps if I leave you with a

speech that I made at a party to celebrate significant birthdays of my sons Tom and Charlie you will get the drift.

I am normally not allowed to give speeches, as Nicky and the boys seem to think that their principal task on these occasions is to make sure that I don't get on my feet and embarrass them. So, I consulted a good friend, who advised me that a good speech should be like a pretty girl's skirt. It should be short enough to arouse interest, but long enough to cover the essentials.

I want to thank Nicky, the person who has made this all possible. As those of you who visit Upper Cheyne Row on a regular basis know, she keeps the fridge full of cheese and bacon, so that you can gorge yourselves when you come in at whatever ungodly hour of the morning. She has worked tirelessly to lay on this event, just as she has always done for the family and our friends when they visit. She is a super Yummy Mummy.

There are four Gayner boys and, if they had all been at school at the same time, they would have been Gayner Maximus, Gayner Major, Gayner Minor, and Gayner Minimus. I was proudly telling a patient about the birth of one of the boys, when he said, 'If it has tyres or testicles, sooner or later, you are going to have trouble with it.'

I have never thought of Tom as Gayner Minor, and I have certainly never thought of Charlie as Gayner Minimus. However, I should like to take this opportunity to tell you a few things about them.

Tom, as you know, has been an ardent Chelsea FC fan and, when he was eight, and Arsenal were in

their pomp with Thierry Henry and Dennis Bergkamp, we had been to see them beat us yet again at Stamford Bridge. It was a damp Saturday afternoon, and we were walking back up the Fulham Road. I had Minimus in one hand and Minor in the other, and Tom looked up at me and said, 'Dad, I don't think that I will live long enough to see us beat Arsenal.' His passion for Chelsea FC started early and has only intensified over time.

I have to say that neither Minor nor Minimus have ever been a problem in terms of discipline. If I felt something was out of order, I would give them a last warning. A look of absolute horror would come over their faces and, 'No, Dad. Not that punishment. No.' Because if they did it again, the punishment was wheeled out, and it was severe. They would not be allowed to go to Chelsea FC that weekend, and their season ticket would be used by the friends of one of their brothers.

"On one such occasion, when I wheeled the punishment out for Tom, he replied, 'Dad, if I cannot go to the Manchester United against Chelsea match, I'm going to kill myself.'

One day, when I was visiting Tom in his room at school, he whispered to me to look at his computer screen. Nicky was inevitably doing a tidy up of his room, and Tom indicated that he only wanted me to see what was on his screen. It transpired that one of his masters had sent him a sort of Google page, with a message about the next essay that he had to write. Unfortunately, on this page the master had carelessly left what he himself had been googling – Soapymassage.com. What appeared when

Tom went into the website to show me the content was 'Hot Asian girls with a happy ending'. I was impressed that none of the class wanted their mothers or the school authorities to know about this. However, they did have their moment of fun in the next class when they all turned to the teacher and said, 'Excuse me, sir, I just want to go out to wash my hands with soapy water.'

All square, and a very mature way of handling the situation.

Gayner Minimus, Charlie, he had a bit of a curious incident in his house at school when, one night, one of the boys decided that he was going to get up and deface one of the doors on the corridor with drawings of genitalia. There was quite a lot of speculation as to who the naughty artist could be. The school's works department came in and removed the offending art but, a week later, the mystery artist went to work again. This happened four or five times. No one ever owned up to it, and in the end, the house had christened the mystery artist 'Wanksy'.

Both Tom's and Charlie's school reports make for interesting reading, and it would be unfair to the boys if I let you know to whom the following comments refer.

One report read, 'French is a foreign language to Gayner.'

And another, 'For Gayner, all ages are dark. In fact, I should add that Henry Ford once said that 'History is Bunk'. Gayner's most certainly is.'

The history master went on, 'When the workers of the world unite, it would be presumptuous of Gayner to include himself amongst their number.'

Another teacher wrote, 'The improvement in his handwriting has revealed his inability to spell.'

And the religious studies master wrote, 'This boy does not need a scripture tutor – he needs a missionary.'

In spite of these comments, I am proud of the hard work that they have both put into achieving firsts at university.

I am happy to pass on advice that I have given to all my sons, as it may be relevant to all of you.

First, never test the depth of the water with both feet.

Second, if at first you don't succeed, skydiving is not for you and, more importantly, there are two excellent theories for arguing with women. Neither one works.

Finally, my medical advice is never, under any circumstances, take a sleeping pill and a laxative on the same night.

I am truly proud to be standing here as the father of Maximus, Ma, Mi, and Minimus, and to admire all of their achievements. Winner of the Micklem Public Schools Golf Championship and media mogul, winner of the Schools National Rowing Eights Championship and two-time international oarsman, sports marketeer winning accounts from the Olympic Committee and, finally, Captain of Football.

I concluded my speech with a toast to my four boys and to Nicky, who has lovingly looked after us all these years.

To the four recipients of the Gayner DNA, I can now pass on the 'mantra', which will hopefully help them through their own adult lives.

Acknowledgements

The author wishes to thank all at SilverWood Books for their help and patience in dealing with a first-time author. Without your help this book would not have been published.

Thanks to others who have helped including Dr David Dance, who checked all the medical parts for correct terminology.

Thanks to all the photographers whose images have recorded a special moment in time.

Every effort to trace copyright holders has been made, and any omissions will be rectified in any future editions of this book.

All profits from the publication of this book will be donated to Wilton's Music Hall to help with the upkeep of the amazing original Victorian interior, and for the continuation of performing arts there. (www.wiltons.org.uk)